Electronic Prepress:
A Hands-On Introduction

Electronic Prepress: A Hands-On Introduction

Bill Parsons

Delmar Publishers™

I(T)P™ An International Thomson Publishing Company

Albany • Bonn • Boston • Cincinnati • Detroit • London • Madrid
Melbourne • Mexico City • New York • Pacific Grove • Paris • San Francisco
Singapore • Tokyo • Toronto • Washington

NOTICE TO THE READER

Cover Design: Spiral Design - Bob Clancy

Delmar Staff:
Senior Administrative Editor: John Anderson
Production Manager: Larry Main

Project Development Editor: Barbara Riedell
Art/Design Coordinator: Lisa Bower

COPYRIGHT © 1995
By Delmar Publishers
a division of International Thomson Publishing Inc.
The ITP logo is a trademark under license

Printed in the United States of America

For more information, contact:

Delmar Publishers
3 Columbia Circle , Box 15015
Albany, New York 12212-5015

International Thomson Editores
Campos Eliseos 385, Piso 7
Col Polanco
11560 Mexico D F Mexico

International Thomson Publishing Europe
Berkshire House 168-173
High Holborn
London, WC1V7AA
England

International Thomson Publishing GmbH
Königswinterer Strasse 418
53227 Bonn
Germany

Thomas Nelson Australia
102 Dodds Street
South Melbourne, 3205
Victoria, Australia

International Thomson Publishing Asia
221 Henderson Road
#05 -10 Henderson Building
Singapore 0315

Nelson Canada
1120 Birchmont Road
Scarborough, Ontario
Canada M1K 5G4

International Thomson Publishing - Japan
Hirakawacho Kyowa Building, 3F
2-2-1 Hirakawacho
Chiyoda-ku, Tokyo 102
Japan

1 2 3 4 5 6 7 8 9 10 XXX 01 00 99 98 97 96 95

Library of Congress Cataloging-in-Publication Data

Parsons, Bill, 1943 -
 Electronic prepress: a hands-on introduction/by Bill Parsons.
carryover line from title/Author's name
 p. cm.
 Includes index.
 ISBN: 0-8273-6449-0
 1. Printing, Practical -- Imposition, etc. -- Data processing.
 2. Desktop publishing. I. Title
Z253.P29 1994
686.2'2544536 --dc20

94-36491
CIP

Contents

Preface

This book is written as a guide for individuals who wish an overview of the desktop publishing and electronic prepress fields. Because it is an overview, in-depth technical discussions have been avoided in this text, and I have attempted to present technical information in a simplified manner. Electronic prepress technology is undergoing rapid development, with a constant flow of new products and technological refinements. I felt that the purpose of this book should be to attempt an objective description of the current state of electronic prepress in general terms, providing an opportunity for students of the field to gain a broader understanding of existing technology and be alert to possible future developments.

Some important concepts, such as communicating with service bureaus and trade shops, halftoning, and process color printing, are presented with some intentional redundancy, although care has been taken to avoid sheer repetition. My feeling is that one often needs to read explanations of difficult concepts more than once, and in different contexts, to develop better understanding. Review questions at the end of each chapter are intended to help emphasize key concepts and insure reading comprehension. Key terms are italicized when they are first used in each chapter, and then they are listed alphabetically at the end of each chapter. Definitions for the terms are located in the Glossary.

A recent merger of the Aldus Corporation with Adobe Systems, Inc. has necessitated changes in the names of some popular products because the postmerger company is known only as Adobe Systems. The illustration software application, formerly Aldus FreeHand, will henceforth be marketed by its original developers, Altsys Corporation, and is referred to in this book as Altsys FreeHand. Aldus Corporation's flagship product, PageMaker, is referred to as PageMaker from Adobe Systems. References

to Aldus PhotoStyler and other Aldus products have not been changed because, at the time of this printing, Adobe Systems had not made any decisions concerning them.

I'm grateful to Vern Anthony of Delmar Publishers for suggesting the topic of this book. I'm also deeply grateful to Barbara Riedell, John Anderson, and others of the Delmar Advanced Technology team for their unstinting support in the writing and publishing of this book. I must thank Henry Hatch, executive director of the International Prepress Association for taking the time to send me much helpful information. Thanks are also due to Linotype-Hell and Scitex America Corporation for providing a wealth of information. I'm grateful to Tony Huet, proprietor of ImageSmiths, a digital imaging company in Dallas, Texas, for insights into desktop scanning. Many thanks go to Ed Waldrup, Systems Consultant at Computize in Dallas, for helping me keep my Macintosh running smoothly, thereby expediting the production of this book. I'm grateful to Lisa Mooney for a gentle, yet thorough, hand in copyediting this book and to Brooke Graves of Graves Editorial Services for an excellent index. I thank Mauricio Estrada for exceptional illustration work and Lisa Bower, Art/Design Coordinator at Delmar, for help with photographic illustrations. Finally, I offer special thanks to my daughter, Courtney, for the frequent use of her lovely image in Chapter 5 and to my loving wife, Juanita, whose constant moral support is inexpressibly valuable.

Bill Parsons

1

When you complete this chapter, you will have learned:

✔ the definition of the term, "electronic prepress".

✔ how the graphics industry has been moving from traditional methods to electronic methods.

✔ the types of software applications being used in desktop publishing and electronic prepress.

✔ how publications are prepared for offset printing.

✔ options for outputting electronic publications.

✔ the importance of clear communication in the delegation of responsibility.

Electronic

Prepress

Technology

Introduction

The term *electronic prepress (EPP),* or *digital prepress,* is used in this book to define the processes, beginning with desktop publishing, of using computers and other electronic equipment to prepare publications for the printing press. These processes include scanning, color adjustment, inclusion of high-resolution digital halftones, trapping, page imposition, stripping and high-resolution output to film or plate.

The graphics industry has experienced a revolution. It's sometimes known as the desktop publishing revolution, and like most revolutions, it has had far-reaching effects and has caused momentous changes in the way things are done. The changes have affected nearly everyone connected with the graphics industry, including graphic designers, typesetters, production artists, illustrators, photographers, prepress technicians, press operators, and printing sales representatives.

This book is an introduction to the desktop publishing and electronic prepress technologies responsible for those changes in the graphics industry. Technological change is so rapid in this field that it is difficult for anyone to keep up with it. No attempt is made in this book to give detailed descriptions of every possible combination of hardware and software or to list and describe every single piece of electronic equipment currently in

use by desktop publishers, service bureaus, color houses, and commercial printing firms. Rather, to provide an easily understood overview of this complicated field, this book discusses major developers and vendors and representative hardware and software only.

In addition, the book discusses the processes of page layout, scanning, color separation, and printing in the most general terms. An effort is made to examine clearly discernible trends. For example, the distinctions between typesetting and graphic design, between design and prepress processes, and between prepress and printing processes are becoming less clear. This book discusses the prepress field primarily in terms of its current and past major function of supporting the printing industry. However, this function is changing as the very nature of printed communications changes. The situation is perhaps best summed up with a quotation from, "Bridging to a Digital Future," a report developed by the Printing Industries of America (PIA): "While predictions abound for the demise of prepress as it is known today, the underlying activities or functions that constitute prepress will not disappear...the focus of prepress is changing from that of supporting printed product to that of producing complex electronic images for delivery in a variety of media formats that may include paper."

Desktop Publishing and Electronic Prepress

In the mid 1980s, the term *desktop publishing* was coined by Paul Brainerd, who was at that time president of the Aldus Corporation in Seattle, Washington. Aldus Corporation developed the first *page layout software* application for the Macintosh computer—Aldus PageMaker (now from Adobe Systems). In this book, desktop publishing (DTP) is defined as the use of *personal computers (microcomputers), scanners, laser printers,* and specific *software applications* to create a wide variety of publications.

Usually, a page layout software application such as *PageMaker* from Adobe Systems or *QuarkXPress* forms the basis of a desktop publishing operation. In the basic operation, text and other typographic elements are

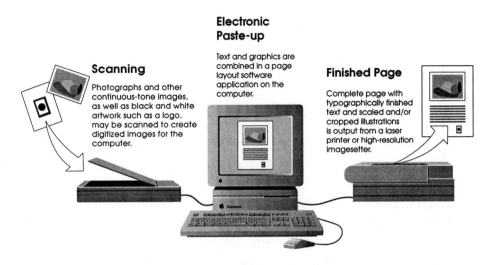

Scanning

Photographs and other continuous-tone images, as well as black and white artwork such as a logo, may be scanned to create digitized images for the computer.

Electronic Paste-up

Text and graphics are combined in a page layout software application on the computer.

Finished Page

Complete page with typographically finished text and scaled and/or cropped illustrations is output from a laser printer or high-resolution imagesetter.

Figure 1-1. The basic desktop publishing process involves the use of specific software applications on a personal computer to create publications. Peripheral devices such as a scanner and laser printer may also be a part of the hardware setup.

created in *word processing software* or directly in the page layout software. Graphic images may be obtained by scanning photographs and other artwork or by creating them in a *drawing or painting software* application such as *Adobe Illustrator* or *Fractal Design Painter.* After text and graphic elements are combined, completed publication pages may be output on a laser printer or a *high-resolution imagesetter.* See Figure 1-1.

The development of relatively low-priced personal computers, such as the *Apple Macintosh* and the *IBM PC,* spurred the desktop publishing revolution, but electronic prepress can involve expensive hardware and software. Some prepress functions are likely to be performed by specialists employed at *color trade shops (color houses), prepress service bureaus* and *commercial printing firms.* This more specialized field is defined as *high-end electronic prepress* and involves the use of *color electronic prepress systems (CEPS).*

A less expensive approach to electronic prepress is represented by *mid-range prepress systems.* These fall somewhere between desktop pub-

lishing and high-end prepress systems in cost and capability. See Chapter 3 for more information on high-end and mid-range electronic prepress technology.

When DTP Becomes EPP

The degree of involvement by *graphic designers* and other desktop computer users in prepress activity depends on the sophistication of available hardware and software and the ability of the individual. For example, a person who creates a simple advertising flyer using a page layout software application on a Macintosh computer and then outputs the final layout on a desktop laser printer at 300 *dots per inch (dpi)* is performing electronic prepress work at its most basic level. The 300 dpi output can be taken to a print shop where a *printing plate* can be made from it. The resulting printed flyers would be adequate for the advertising purposes of many businesses. In fact, this type of prepress activity is quite widespread now that desktop publishing technology has become so popular.

A Matter of Choice

If the printed piece is to incorporate more than one color of ink, if photographs are involved, or if a very high *output resolution* is desired, then the process becomes more complicated. Today's desktop publishers can choose how involved they want to be in that process. For example, a person with access to a powerful computer, a good scanner, and software such as QuarkXPress and Adobe PhotoShop can perform advanced prepress activities by scanning and adjusting color photographs and controlling the *trapping values* of *color separations*. Such an individual is deeply involved in prepress technology and may have computer publications output directly to *film negatives* or printing plates on a high resolution imagesetter.

The Publishing Process

In the past, prepress work was exclusively done by people trained to do specialized jobs. Publications were usually conceived and designed by graphic designers and others whose expertise lay primarily in art and editorial functions. *Camera-ready artwork* was handed over to the specialists employed at a printing firm, and the next time the originator saw the publication, it was in the form of a *proof* copy which showed how the publication would look when it came off the press. For the sake of discussion in this book, we will call this the *traditional publishing process.* The traditional process has all but given way to the use of personal computers in what we will call the *desktop publishing process.* Now let's compare the two processes.

The Traditional Process and the Desktop Process

In both the traditional process and the desktop process, a publication begins when it is conceived and designed. The designer uses rough sketches and a fully-realized mock-up called a *comp* (abbreviation of *comprehensive)* to communicate the design concepts to others involved in the project. Comps can be quite elaborate. They may utilize the actual paper stock that the job will be printed on, and, in the traditional method, show color elements rendered by marker, paint, or colored paper. In the desktop method, the comp can be much more accurate at showing what the publication will eventually look like when it's printed on a printing press. Since the publication is being created on a computer, all the text and graphic elements can be rendered in more or less their final state. The publication can then be output to a *color printer,* showing colors, typography and other elements much more accurately than a traditional handmade comp ever could.

Creating Mechanicals

At this stage, it's not unusual for several individuals to be involved in the project. In an advertising agency, for example, an account executive or cre-

ative director will probably be act-ing as liaison between the client and the art director or designer. In addition, a copywriter and produc-tion manager might be a part of the team. After the design concept has been established, it's time to begin creating the *mechanicals* for the project. Mechanicals are also called *camera-ready art,* and they constitute the basic layout of the printed piece. In the traditional method, mechanicals are created by adhering pieces of paper to a sheet of poster board. The pieces of paper contain typeset copy and artwork such as logos and illustra-tions (see Figure 1-2). This process is known as *pasting up.* Additional elements, such as windows for photographs, may be added to the mechanical on clear acetate over-lays. Creating a mechanical requires good manual dexterity and attention to detail.

Traditional Typesetting

The typeset copy pasted up on a mechanical comes from sheets called *type galleys* which are obtained from a typesetting machine. Before desktop publish-ing, the most recent common method of typesetting was *photo-*

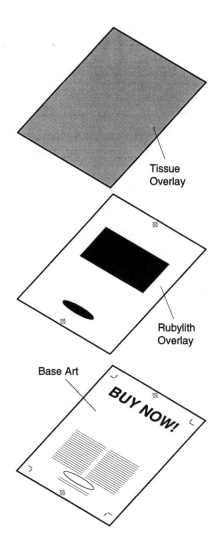

Tissue Overlay

Rubylith Overlay

Base Art

BUY NOW!

Figure 1-2. A mechanical consists of elements which will be used to create negatives and printing plates. An acetate overlay is used for sepa-rate color elements and windows for photographs. A tissue paper overlay may be added as a place to write instructions. In this example, the base art portion contains all ele-ments that are to print in black ink.

typesetting. It is still in use but has mostly been replaced in this country by desktop publishing. In phototypesetting, type characters are formed by projecting the image of the character from a master negative onto photographic paper. The photographic paper comes on rolls and it leaves the processing machine in a long strip, or galley, which is then cut apart as the mechanical is created. An adhesive such as sticky wax, rubber cement, or spray-mount is used to adhere the pieces of type galley to the paste-up board. Phototypesetting and all previous typesetting technologies usually relied on the skills of professional typesetters. It is the responsibility of the publication designer to mark copy for the typesetter, communicating requirements for typeface, size, style, and so on. This is usually done on copy generated on a typewriter or word processor.

Incorporating Graphic Images

Illustrations, photos, and other artwork can be incorporated in the mechanical by photographic reproduction. In the traditional method, any artwork created with pen and ink, pencil, paint, marker, or any other traditional art medium can be photographed with a special graphic arts camera known as a *process camera*. Process cameras are also used to make plates or negatives by photographing the mechanical. They use a very sensitive film that will even record dirt, smudges and the edges of pasted-down elements on the mechanical. Consequently, mechanicals must be kept very clean and neat. The camera can record black, red, or amber (orange brown) but not light blue, so a non-reproducing light blue pencil or marker can be used to write instructions to the prepress technicians or create guidelines for the elements to be pasted on the mechanical. Expertly operating a process camera requires great skill and years of training, especially when it is used to create color separations. Desktop and high-end scanners are steadily replacing the process camera, but many are still in use.

The Purpose of Halftones

After the artwork is photographed with a process camera, a print, usually called a *stat* or *PMT (photo-mechanical transfer)*, is made for the pur-

pose of pasting into the mechanical. At one time this was the only way one could have a piece of artwork reduced or enlarged. If the artwork is of the type known as *continuous tone,* it has to be photographed as a *halftone.* A continuous tone image is composed of shades of color or gray that blend into each other to form a continuous variation of tonal values.

Continuous-tone art is usually a photograph, but it could be a painting done in ink wash, watercolor, oils, etc. A halftone converts the continuous tones into dots as this is necessary to print the image on an *offset printing press.* The photographic method of producing halftones is still widely in use but is rapidly being replaced with the computer-generated digital method.

In some instances, especially when halftones are involved, a photographic print is not used for pasting up. Instead, a *Rubylith* or *Amberlith* window is created in the mechanical into which the halftone or other art can be inserted during the traditional prepress procedures. Rubylith and Amberlith are brand names of an acetate sheet which carries a thin film of red or amber that can easily be cut and peeled away. A piece of acetate sheet is taped as an overlay on the paste-up board and the red or amber film peeled away to leave rectangles or other shapes for the halftones or other illustrations. See Figure 1-2.

Since the mechanical itself will be eventually photographed to obtain negatives for making offset printing plates, the red or amber windows will be seen as solid black by the process camera. Thus, they appear on the negatives as clear windows. In fact, any area of color that is a part of the publication design must be established on the mechanical with an overlay of Rubylith or Amberlith. Lines, also called *rules,* are incorporated in the mechanical by either drawing them with a technical pen or using a special kind of tape.

Traditional Tools of the Trade

A traditional mechanical is created with tools that have always been associated with architectural and mechanical drafting (see Figure 1-3). A drawing board usually forms the basis of a traditional graphic arts work area. A *T-square* and *triangles* or a sophisticated mechanical *drafting*

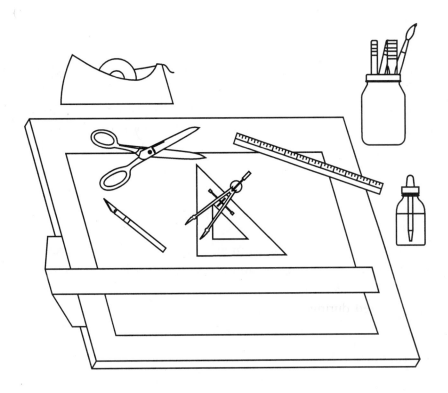

Figure 1-3. Drafting equipment and other common materials and tools, such as rubber cement, scissors, and tape, are used to create a traditional mechanical.

machine are used to provide precise horizontal and vertical axes to keep elements aligned. An *X-acto knife* or other sharp blade is often used to cut typeset copy from the galley or trim the edges of a stat prior to pasting the element down on the mechanical. To attach pieces of typeset copy or stats, rubber cement or adhesive wax is most often used. The adhesive wax is perhaps the best method as it allows elements to be repositioned more easily. Wax must be applied with a mechanical device which melts it and spreads it in a solid area on the back of the element to be pasted up. Other items such as burnishers, rulers, erasers, markers, technical pens, and plastic drawing templates make up the balance of the traditional graphic design toolbox.

The Digital Mechanical

The process of creating a traditional mechanical is being replaced by the desktop method. In the desktop method, the mechanical is created entirely in a computer. Type is created and formatted in the computer, and photographs and other artwork are either scanned or created in the computer. The computer replaces the traditional typesetting procedure, and the scanner replaces the process camera. When images are created by a scanner, they are said to be *digitized images*. The term *digital* is often used to describe the functions of a computer, referring to the numerical basis on which a computer processes data. Desktop publishing allows type and graphic images to be combined electronically in a manner which might be thought of as a metaphor for the traditional paste-up board. The resulting mechanical can be an almost exact representation of the final printed piece.

The Software Base

The basis of the desktop method is a software application which provides the electronic paste-up board. This type of software is known as page layout software. Two have dominated the field so far—PageMaker and QuarkXPress. They are both available in Macintosh and *Microsoft Windows* versions. Other page layout software includes *Corel Ventura* (formerly Ventura Publisher), *FrameMaker,* and *Ready, Set, Go.* Ventura is now part of a Windows software package including CorelDRAW!, a popular vector drawing program. FrameMaker is a sophisticated publishing package that is available for both Mac and Windows. Ready, Set, Go is a perfectly good, but rather unpopular, page layout application for the Mac.

Page layout software allows the user to exercise complete control over typographic elements. In fact, the amount and ease of control exceeds that of any previous typesetting technology. The only problem with this revolutionary technology is that many of the people working with type in a page layout software application are not professional typesetters or graphic designers. Consequently, many of the resulting publications do not have the finesse that a professional hand would apply. For example, a novice

will often combine inappropriate typefaces or utilize type sizes and styles incorrectly. It seems that this is merely a matter of education, however, and individuals who are working with page layout software are learning that there is often more to a printed page than first meets the eye.

The benefits of computer-generated type are many. Easy access, rapid revisions, vast choice of fonts, and sheer economy are only some of the reasons computer typography is so successful. Figure 1-4a and Figure 1-4b illustrate and compare the traditional and desktop prepress methods.

Software Applications

Before continuing our discussion of electronic prepress, we will briefly describe some of the most popular desktop publishing and graphics software applications. They are categorized into three main types of software: (1) page layout; (2) illustration; and (3) image manipulation.

Page Layout Software

As mentioned earlier, standard *page layout software* applications form the basis of desktop publishing and electronic prepress. Special *proprietary software,* such as *Hell ScriptMaster, Scitex Visionary,* or *Crosfield StudioLink,* is used in high-end prepress operations to link desktop software with the *high-end scanners* and *film recorders,* but these will be discussed in Chapter 3, "Prepress Systems and Service Bureaus." Here we will discuss the two widely-used desktop publishing applications, PageMaker and QuarkXPress.

PageMaker and QuarkXPress

PageMaker and QuarkXPress are fierce competitors, and users are often equally fierce in their advocacy of one or the other of these software applications. The two software companies are constantly changing and improving their products to meet the demands of the market, and PageMaker and QuarkXPress are both excellent page layout software

TRADITIONAL PUBLISHING PROCESS

1 Concept and Design

The project begins with a pencil rough or a color comp. Discussion among individuals involved in the project results in a final design.

2 Typesetting

Type is set by a professional typesetter from copy prepared by the designer, copywriter, or editor. Type galleys are returned to the designer or production artist. Changes require additional typesetting time and expense.

3 Camera Work

Photos, logos, and other illustrations are sized to fit the layout and photographed with a process camera. Prints, or stats, are returned to the designer or production artist.

Figure 1-4a. The traditional publishing process involves many separate stages and individuals.

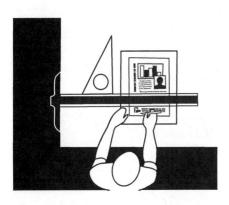

4 Camera-Ready Mechanicals

The designer or production artist prepares a mechanical by pasting up type and graphic elements.

5 Final Camera Work

The process camera is used to make film negatives or positives from the paper mechanicals. Color separations for spot colors and color halftones are also made at this point.

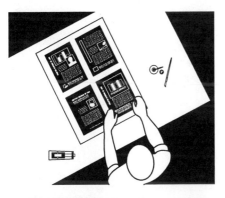

6 Stripping

The film is prepared for plate-making by a stripper who assembles all the pages and other elements.

7 Printing Press

Printing plates are made and the project is printed, folded, and bound.

Illustrations by Mauricio Estrada

DESKTOP PUBLISHING PROCESS

1 Concept, Design, and Typography

The project may still begin with a pencil rough, but it's just as likely that it will begin on a computer because design changes can be so easily made. Text is generated in a word processor or directly in a page layout application. Typographic changes are easy to make at any stage.

2 Graphics

Graphic elements are digitized with a scanner or created in a graphics software application. Special effects and color adjustments can be applied with image manipulation software.

Figure 1-4b. The desktop publishing process has replaced the traditional publishing process because it is more efficient and usually more economical.

3 Electronic Mechanicals

Text and graphics elements are combined in a page layout software application. Color information is an integral part of the publication file.

4 Electronic Stripping

Further adjustments, such as inserting high-resolution digital halftones or trapping colors, may be made to the electronic mechanicals by a professional prepress service provider, or the publication may be output directly to film or printing plates on a high-resolution imagesetter or film recorder.

5 Printing Press

Printing plates are made, and the project is printed, folded, and bound. Some types of digital presses do not use plates, or the plates are made on the press through digital imaging.

Illustrations by Mauricio Estrada

applications. Both are available in Macintosh and Windows versions. Any statements regarding which product is "better" are essentially subjective and affected by personal bias. Objectively, the two software applications are approximately equal in their ability to generate sophisticated publications. Keep an open mind, and realize that you should be familiar with both to achieve maximum success in a graphic arts career.

How They Work

A page layout software application allows the user to electronically combine text and graphic elements such as scanned photos, illustrations, and lines and boxes. PageMaker and QuarkXPress each take a completely different approach to the process of incorporating elements into the electronic layout, but there are many similarities, especially in typographic features. Both applications can import a wide variety of file formats.

Both applications create on the monitor screen a clearly defined layout page and pasteboard area contained within a document window. This page can be any size up to 48 x 48 inches in QuarkXPress and 42 x 42 inches in PageMaker. Both applications allow text and graphic elements created in other software applications, such as word processors and drawing and painting programs, to be imported into the publication layout. *Scanned images* can also be imported. It is in the manner that these elements are displayed on the page layout that the two programs differ most.

In PageMaker, imported text and graphic elements are placed directly on the layout page where each element can be manipulated as a discrete object. Text flow is controlled either by column guides or by adjusting the size of the text object. Graphics appear in much the same manner as they do in their originating software.

On the other hand, to import text or graphics into QuarkXPress, a box must be created to contain the element. Text boxes are created for text, and picture boxes are created for graphics. Text boxes control the flow of text and can be formatted with column guides. Picture boxes display graphic images accurately, but the edges of all boxes are always apparent unless guide display is disabled. Figures 1-5 and 1-6 show a page layout as it appears in PageMaker and QuarkXPress respectively.

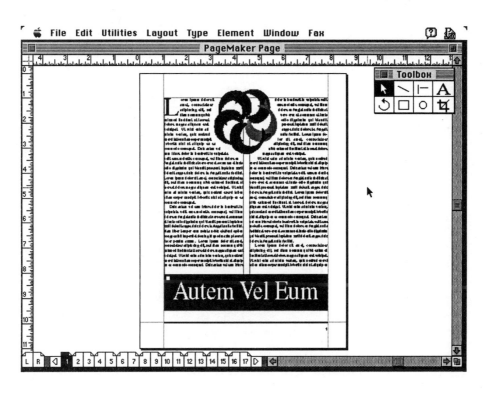

Figure 1-5. PageMaker for Macintosh displays a layout page containing text and graphic elements. The toolbox in the upper right contains tools for selecting and moving objects, drawing lines and boxes, creating text, rotating objects, and cropping. Dotted horizontal and vertical lines indicate column guides and ruler guides which aid in the placement of elements on the page. PageMaker for Windows has a very similar appearance.

Both software applications have similar typographic features to format font, size, style, character width, *kerning* and *tracking,* etc. Graphics can be resized, cropped, rotated, skewed, and flipped in both applications. Both applications have word-processing features such as spell checking and search and replace. Text and simple graphics such as lines and geometric shapes can be created directly on the layout page in both PageMaker and QuarkXPress. Other common features include style sheets, digital halftone manipulation, text wrap-around on graphics, color formatting and separation capabilities, and library files for storing text and graphic elements.

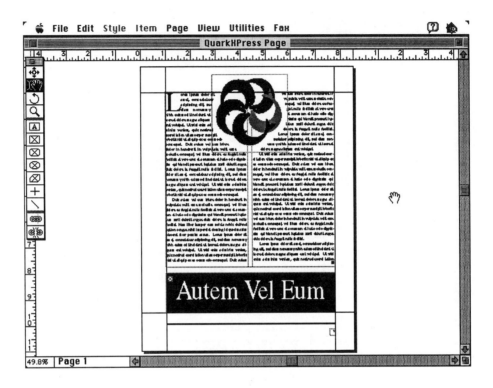

Figure 1-6. QuarkXPress for Macintosh displays a layout page similar to that in PageMaker. Vertical and horizontal guides indicate columns and margins as they do in PageMaker, but in QuarkXPress, each element is contained in either a text box or a picture box. The picture box for the dolphin graphic at top center is the most apparent in this illustration. The tool palette on the left side of the window contains tools for moving objects, creating text, rotating objects, zooming, drawing text and picture boxes, drawing lines, and linking text boxes. QuarkXPress for Windows has a very similar appearance.

QuarkXPress provides built-in *color trapping* features. Trapping in PageMaker can be accomplished with an add-on called *TrapMaker*. Indexing, table of contents, and book assembly features in PageMaker give it an advantage for long documents. Both software companies have made arrangements with other developers to provide software adjuncts which address specialized needs or enhance the basic features. In QuarkXPress, these are called "XTensions;" in PageMaker, they are known as

"Additions." XTensions and Additions perform such functions as color management (EfiColor XTension) and creating printing signatures (Build Booklet Addition).

Illustration Software

Illustration software can be placed into two broad categories: (1) *vector image* and (2) *bitmap image.* Vector and bitmap images created in illustration software can be imported into page layout applications. Vector images (also called *object-oriented*) are processed much differently from bitmap images. The size and shape of a vector image is defined mathematically in the computer, and the final dpi (dots-per-inch) resolution of such an image is determined by the *output device.* In other words, a vector image output on a basic desktop laser printer will have a 300 dpi resolution, but the same image output on a high-resolution imagesetter might have a resolution of 2,540 dpi. Reducing and enlarging a vector image has no effect on its resolution. Bitmap images, however, maintain an image-size/image-resolution ratio that is not affected by the resolution of an output device. The computer processes the bitmap file as *pixels* with a fixed size and relationship to each other. Thus, a 72 dpi bitmap image printed on a 300 dpi laser printer will remain at 72 dpi. Reducing bitmap images will increase their resolution; enlarging them will decrease it.

Both PageMaker and QuarkXPress are capable of importing a variety of computer graphics file formats. Some of the most common bitmap formats are *Paint* and *TIFF (Tag Image File Format),* and most vector images are *PICT (draw)* or *EPS (Encapsulated PostScript).* The EPS format is particularly important in electronic prepress processes because it allows graphic images to be recognized by a variety of software applications. EPS files are created by *PostScript* drawing programs such as *Adobe Illustrator* and *Altsys FreeHand.* PostScript is a programming language developed by Adobe Systems, Inc. It is a page description language that has become the standard for both typographic and graphic image output.

Popular vector image software applications for the Macintosh include Adobe Illustrator, Altsys FreeHand, and *Deneba Canvas.* Illustrator, FreeHand, and Canvas all come in Windows versions, but *CorelDRAW!*

and *Micrografx Designer* are popular with Windows users. *SuperPaint* (Macintosh) and *Fractal Design Painter* (Mac and Windows) are two excellent bitmapped image or "paint" programs. Three-dimensional drawing packages such as *Ray Dream Designer* are becoming increasingly popular with illustrators. All these software applications have full color capability and can be used to create images ranging from simple charts and graphs to sophisticated advertising illustrations. Professional illustrators may need to be familiar with several software applications to fulfill the needs of their clients.

Image Manipulation Software

This category of software is most often used in conjunction with a *desktop scanner* and is well represented by *Adobe PhotoShop* (Mac and Windows) and *Aldus PhotoStyler* (Windows). These software applications contain tools and features which allow *digitized images* obtained from scanners to be manipulated in many ways. A digitized image can be made from a black and white or color photograph or any kind of continuous tone art. A digitized image is basically a bitmap and these programs work by manipulating the individual pixels that make up the image. With image manipulation software you can modify brightness and contrast, drop out unwanted backgrounds, retouch and alter, sharpen or blur, clone, apply special effects, and so on. All sorts of color modifications can be performed with PhotoShop and PhotoStyler, making them valuable tools for electronic prepress color separation and correction.

Image Assembly and Stripping

Photographic images and other artwork can be easily incorporated into an electronic (or digital) mechanical. In some instances, though, final images are not incorporated in the electronic mechanical. Often, a low-resolution scanned image is used as a position-only design element, and the final high-resolution scanned image is inserted during the final stages of the prepress procedure. Low resolution images used in this way are

sometimes referred to as *placeholders* or *for position only (FPO)* images. In both the traditional and the desktop methods, the procedure of combining photographs and other images with typographic matter at a stage just prior to making printing plates is known as *stripping*.

The Traditional Way

Traditional stripping is a procedure requiring many skills, especially manual dexterity. In traditional stripping, the film negatives (and sometimes positives) that result from photographing the mechanicals are assembled together by taping them onto a sheet of orange or yellow colored paper or plastic called *masking sheets*. The images in the negatives (or positives) that will be used to make the printing plates are exposed by cutting away the masking sheet. Such an assembly of film and colored paper backing is called a *flat*. Depending on how the publication is to be printed, a flat may contain many pages and will incorporate halftone negatives as well. Since the flat is used to make offset printing plates, it represents a *press layout* which may be quite different from the *designer's layout* represented by the mechanicals. (NOTE: In the United States, the most common method of printing reproduction is offset printing. Offset printing and other printing methods are discussed in Appendix A.)

In offset printing, a printing plate is made from the flat when the negatives and/or positives it contains are exposed onto plates that have a photosensitive surface. This process of making plates is known as the *photomechanical process*. Two terms, *image assembly* and *imposition* are used to describe the whole process of working with film negatives and positives to assemble the stripped flats. In the traditional method, strippers must trim the film, hide flaws such as small pinholes by covering them with an opaque fluid, square up halftones, register color separations, and create traps. The finished flat may represent one whole side of a two-sided publication such as a pamphlet or brochure, but may also represent many pages of a multiple-page publication such as a catalog, magazine, or book. The pages of these larger publications are arranged into groups (the *press form*) of two to 64 pages, depending on the type of printing press. These groups of pages are called *signatures* after they are printed.

Three different arrangements of pages, or *imposition forms,* are used for printing: (1) work-and-turn; (2) work-and-tumble; and (3) sheetwise. Which imposition plan to use is determined by factors such as the type of press, the size and orientation of the printed piece, and the number of pages in the publication. After film has been assembled, *proofs* are made. The purpose of a proof is to show as closely as possible how the publication will look when it is printed. This is also the purpose of a comp, which we discussed earlier in this chapter. However, a proof made from the final film negatives can be more accurate because it shows the quality of halftones, reverses, bleeds, and color. There are several types of proofs, and these are discussed in Chapter 6.

Electronic Stripping and Digital Prepress Systems

The traditional prepress procedures described above require many time-consuming steps and much manual skill. There are several stages in the procedure where the slightest inaccuracy can be detrimental to the finished printed piece. For example, color separations for color photographs must be registered very accurately, or the printed image will be fuzzy and "off-register." Also, folding and binding effects must be precisely compensated for during page imposition.

New electronic prepress methods have done much to improve accuracy and have greatly accelerated the process of page imposition, stripping, and image assembly. In a best case scenario, electronic prepress utilizes scanners, computers, and high-resolution output devices to replace all the tedious steps of color separating, color correction, image modification, page makeup, page imposition, stripping, and proofing. It is certainly true that traditional stripping methods are still in use—mainly due to the high cost of outputting very large sheets of film containing electronically imposed pages for printing signatures. As mentioned earlier in this chapter, electronic prepress processes begin with desktop publishing and, depending on color-quality requirements, may move on to mid-range or high-end digital prepress systems. These systems are discussed in Chapter 3, "Prepress Systems and Service Bureaus."

Final Output

Several options exist for outputting desktop publications. Assuming that the publication will be printed on an offset press or by some other means of mass reproduction, the computer file containing the page layouts *(electronic mechanicals)* can be output to paper or film on a laser printer or on a high-resolution imagesetter. That output can then be used to make printing plates. It is even possible to output directly to printing plates.

The most obvious difference between laser printers and imagesetters is the resolution. Laser printers provide output in the 300 to 1,200 dpi range, and imagesetters work in the 1,200 to 4,000 + dpi range. Another major difference is in the quality of the output. Although a 1,200 dpi laser printer and 1,200 dpi imagesetter have the same resolution rating, output from the imagesetter will usually look better due to its photographic quality. A toner-based laser printer simply cannot provide as sharp an image as the photographic process used in an imagesetter. The difference is especially apparent in *digital halftones.*

If a printing press is not the ultimate goal, then a laser printer, color printer, or color copier may be the final output device. Allowing for the image quality limitations inherent in such devices, it's not unreasonable to reproduce hundreds of copies of a publication. Some businesses routinely reproduce letters, business cards, advertising flyers and so on with their laser printers. Even full color brochures can be economically produced on such devices as a Canon photocopier fitted with a Fiery controller. The Fiery controller (developed by Electronics For Imaging) is a PostScript interpreter which creates good continuous-tone color images. This kind of final output for business presentations and short-run color is an important aspect of electronic publishing.

Taking Responsibility

An important issue confronting anyone who gets involved with electronic prepress technology is that of responsibility for quality and accuracy, especially during the final stages of the process. In the traditional prepress method, responsibility is clearly defined by the processes themselves. It is

the responsibility of the graphic designer or production artist to prepare a workable mechanical, although the quality of a mechanical may vary widely, depending on the experience and skill of its creator. The process camera operator and the stripper then take responsibility for turning the paper mechanical into a set of film negatives or positives that are used to make a printing plate. Other technicians then take over the job, and see that it is printed, folded, and bound.

Even in mid-range and high-end electronic prepress processes, technically trained personnel take responsibility for high-resolution color scanning, electronic stripping, and color trapping. It is in the everyday desktop publishing prepress work that a "responsibility crisis" may occur.

Who Does What?

The crisis often involves expense and expertise in such issues as who will be responsible for determining the color matching system, color trapping, color correction or adjustment, image enhancement or special effects, lines-per-inch settings, and so on. A graphic designer or production artist may be skilled enough to provide final computer files that can simply be output to film or plates that require no further manipulation before printing. This is the most cost-effective route. It does require more sophisticated, and therefore more expensive, hardware and software.

However, not everyone involved in desktop publishing has those skills, nor do many individuals even wish to cultivate them. We are tempted, and even challenged, to do all the prepress work on our own computers. After all, today's computers and graphics software applications are powerful enough to allow us to do so.

Some work, such as trapping, still involves considerable knowledge of the software tools, but the line dividing the designer's responsibility and the prepress technician's is no longer as clear as it once was. Unless a graphic designer or desktop publisher is willing to be responsible for upholding quality standards, they should give that responsibility to a prepress service bureau or printing firm by paying a little more to have the job done right. The question every originator of a desktop-published job should ask themselves is: "If there is a problem, who is responsible?"

Communicate!

The key for success in any prepress situation is good communication. The responsibilities should be agreed upon at the outset, and the originators of a desktop-published job should understand the limits inherent in the process. For example, a specific color desired by a designer for a 4-color job may require a fifth ink color; or certain special effects created on a computer may not translate well on the printed page. As a matter of fact, computer publication files are frequently so complex that problems arise when the files are output. Would-be desktop publishers are sometimes appalled to find that there is so much more to the process than the popular press and software company advertising allows.

Desktop publishing and electronic prepress technologies form an exciting and increasingly complex field. From a modest beginning in the mid 1980s, desktop publishing has become a huge industry responsible for producing everything from simple small-business advertising flyers to slick magazines and premium books. Continuing improvements in existing hardware and software and innovative new products will make the industry even more interesting in the future. ▲

Chapter 1 Review Questions

1. Typesetters have not been affected by the desktop publishing revolution (circle correct answer). True or False?

2. What kind of software application usually forms the basis of a desktop publishing operation (circle correct answer)?

 a. page layout software

 b. drawing software

 c. database software

3. Desktop publishing is the beginning stage of electronic prepress (circle correct answer). True or False?

4. A mock-up of a publication which is used to communicate the design concepts to others is called a _____.

5. Another name for "mechanicals" is _____

 _____.

6. Type galleys are (circle correct answer):

 a. fonts used on a computer.

 b. sheets of typeset copy from a typesetting machine.

 c. a kind of ship used by the ancient Romans.

7. In the traditional mechanical, photos and other artwork can be

 incorporated by _____ reproduction.

8. Special graphic arts cameras are known as _____

 or _____cameras.

9. Photographs are considered to be continuous tone images (circle

 correct answer). True or False?

10. Continuous tone images can be reproduced on an offset printing

 press only if they are converted to (circle correct answer):

 a. drawings.

 b. mechanicals.

 c. halftones.

11. In graphic design, another name for lines is _____.

12. One of the tools used to keep elements lined up squarely in a traditional mechanical is a _____.

13. In the desktop method, the mechanical is created entirely in a computer (circle correct answer). True or False?

14. When images are created by a scanner, they are said to be

_____ images.

15. What is one benefit of computer-generated type?

16. A low-resolution image used as a position-only design element in an electronic mechanical is sometimes called a _____

_____.

17. Briefly describe the stripping process.

18. A flat usually represents the (circle correct answer):

 a. press layout.

 b. designer's layout.

 c. layout of a printing plant.

19. What is image assembly?

20. A group of from two to 64 pages printed on a printing press is called

 a _____.

21. Very high quality color reproduction may require the use of (circle

 correct answer):

 a. mid-range or high-end prepress systems.

 b. an ink-jet printer.

 c. Pantone colors.

Key Terms from Chapter 1

Adobe Illustrator
Adobe PhotoShop
Altsys FreeHand
PageMaker
Aldus PhotoStyler
Amberlith
Apple Macintosh
bitmap image
camera-ready art
color electronic prepress
 systems (CEPS)
color printer
color separations
color trade shop (color house)
color trapping
commercial printing firm
comp (comprehensive)
continuous tone
Corel Ventura
CorelDRAW!

Crosfield StudioLink
Deneba Canvas
designer's layout
desktop publishing
desktop scanner
digital
digital halftone
digital prepress
digitized image
dots per inch (dpi)
drafting machine
drawing software
electronic mechanical
electronic prepress (EPP)
EPS (encapsulated PostScript)
film negatives
film recorder
flat
for position only (FPO) image
Fractal Design Painter

FrameMaker
graphic designer
halftone
Hell ScriptMaster
high-end electronic prepress
high-end scanner
high-resolution imagesetter
IBM PC
image assembly
image manipulation software
imposition
imposition form
kerning
laser printer
masking sheet
mechanical
Micrografx Designer
Microsoft Windows
mid-range prepress systems
object oriented
offset printing press
output device
output resolution
page layout software
paint
painting software
pasting up
personal computer
 (microcomputer)
photomechanical process
phototypesetting
PICT
pixel

placeholder image
PMT (photo-mechanical transfer)
PostScript
prepress service bureau
press form
press layout
printing plate
process camera
proof
proprietary software
QuarkXPress
Ray Dream Designer
Rubylith
rules
scanned image
scanner
Scitex Visionary
signature
software application
stat
stripping
SuperPaint
T-square
TIFF (tag image file format)
tracking
traditional publishing
trapping values
TrapMaker
triangles
type galleys
vector image
word processing software
X-acto knife

When you complete this chapter, you will have learned:

✔ basic terminology associated with computers.

✔ about the different types of computer memory.

✔ the difference between Macintosh and PC operating systems and why the graphical user interface (GUI) is important in desktop publishing.

✔ what makes the Power Macintosh different.

✔ how Microsoft Windows relates to PC operating systems.

✔ to identify the different types of computer input devices, monitors, and data storage devices.

✔ how data can be shared among computers.

✔ the characteristics of peripheral hardware such as scanners and laser printers.

Desktop

Publishing

Hardware

Personal Computers

So many variations on the basic desktop computer now exist that choosing one for desktop publishing is no simple matter. Not too long ago, the *Apple Macintosh computer* had a clear advantage for graphics work, but *DOS-based computers* descended from the original *IBM PC* and its clones have become serious contenders. (*DOS* is an acronym for *Disk Operating System.*) In fact, the venerable DOS itself could give way to other PC operating systems such as *Windows NT* and *OS/2.* For a brief period, *UNIX*-based computers, such as the *NeXT,* were considered the coming thing for desktop publishing, but there seems to be a general move away from that platform. With increasing cooperation between IBM and Apple, an entirely new type of "super" computer may appear on the market very soon, making all else obsolete. The future of personal computers is predictable only in the most general terms, and serious computer users are carried along in a swift current of change where constant updates of both hardware and software are necessary.

In this chapter, we will examine both the Macintosh and the PC and discuss the operating systems in general. Which one to purchase is often a subjective decision based on personal preference. It's not within the scope of this book to weigh all the pros and cons, but a wealth of information

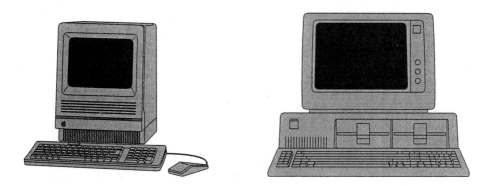

Figure 2-1. The early Macintosh computer (left) and the IBM PC computer (right) were very successful by the mid-1980s.

exists in periodicals such as *Macworld, MacUser, Publish, PC Magazine, Byte,* and many others. Back issues with articles covering just about every conceivable aspect of the various computers, operating systems, software applications, and peripheral devices can be found at the local library or used book store.

Computer Basics

Two terms, *bit* and *byte,* are used to define and measure data processing and storage on a computer. The term bit is used to identify a computer's data processing ability. The first widely-marketed personal computers were eight-bit or sixteen-bit systems. Today's personal computers are twenty-four-bit or thirty-two-bit systems. A bit represents a pulse of electricity in the circuits of the computer and is symbolically represented as either 0 or 1. All data is processed in a computer through groupings of bits. The processing of the digits 0 and 1 is called the *binary process.* The most basic computer operations rely on binary processing, but more complex processing requires other data-organizing systems such as *ASCII code* where the 0s and 1s are grouped into eight-digit codes. Another information processing system known as *logic* relies on electronic switching based on the logic rules of AND, OR, and NOT.

Computer Memory

In the ASCII code, a byte represents a group of eight bits that process information together and represent a single character. Computer memory is expressed in terms of *bytes, kilobytes (K), megabytes (MB), or gigabytes (GB)* as follows: one kilobyte = 1,024 bytes; one megabyte = 1,024 kilobytes; one gigabyte = 1,024 megabytes; one terabyte = 1,024 gigabytes. Computer memory is of three basic types, *RAM, ROM,* and *storage memory.*

RAM, or *random access memory,* exists only when the computer is turned on and is used to store software instructions and other data while they're being used. In the simplest terms, RAM is used by the computer's software to perform all the functions of the software. For example, when you create a page layout in QuarkXPress, RAM is being used to store the instructions for each move you make, such as applying typographic attributes and color or importing and manipulating graphic images.

Typically, sophisticated software applications require more RAM than simple ones. For example, QuarkXPress may require a minimum of 3,000K (3MB) but will operated better if it can access 3,500K or more. A simple word processor such as MacWrite may require only 590K. Because the computer's operating system must also use RAM, it is necessary to have enough installed to accommodate all your software requirements. In electronic prepress operations, 8MB of RAM is considered a bare minimum on the Mac and on PCs running Windows. The Power Macintosh 8100 can contain up to 264MB of RAM. RAM is installed in a computer as special memory circuits or chips called *SIMMs (single inline memory module).* One SIMM can contain from 1MB to 32MB of RAM.

ROM *(read-only memory)* is permanently encoded in a memory chip and is used by the computer to start up and perform other very basic functions. Unlike the volatile RAM, which is wiped out when the computer is turned off, ROM cannot be modified and will not be wiped out when power goes off.

Storage memory is used to store large amounts of data. For example, a newly created document exists only in RAM until it is saved to storage memory. If the power goes off or the computer crashes while data is in RAM, but not saved to storage memory, the data may be lost. Storage

memory is more or less permanent and is represented by *hard drives, diskettes, removable cartridge drives,* and other devices. Some computer operating systems, such as the Macintosh's, can utilize storage memory as RAM. This is called *virtual memory,* and it allows data in RAM to be temporarily stored on a hard disk. This is just a simulation of RAM, but it can be helpful if the computer only occasionally needs more of this type of memory during unusually complex operations. Virtual memory is much slower than actual chip-based RAM and should not be thought of as a substitute for the real thing.

Two other types of memory of importance to electronic prepress computing are *VRAM* and *cache memory. VRAM (video random access memory)* holds video data representing the images on a computer's monitor screen. Cache memory is very high-speed memory that contains the most recently or commonly used data being processed by the computer. Memory modules for cache memory are separate from the regular RAM chips. Cache memory is accessed directly by the computer's processor and is much faster than RAM.

The Apple Macintosh

The first widely-marketed personal computer with a *GUI (graphical user interface),* the Apple Macintosh is usually referred to as the "Mac." The graphical user interface is the defining feature of Apple's Macintosh *operating system.* An operating system is software which allows the computer to perform its basic functions. No matter what other software may be present, a computer cannot function without an operating system. Before the Mac GUI (pronounced "gooey") was developed, small computers mostly worked in a linear fashion where commands were given by typing on a keyboard. The commands and other activities going on in the computer were displayed character-by-character and line-by-line on the monitor screen. This character-based command and response routine is still the basis of DOS.

In contrast, the Macintosh GUI created a non-linear operating environment in which the user could use a *mouse* to choose commands from *pull-down menus* and click on *icons* to access files and software applica-

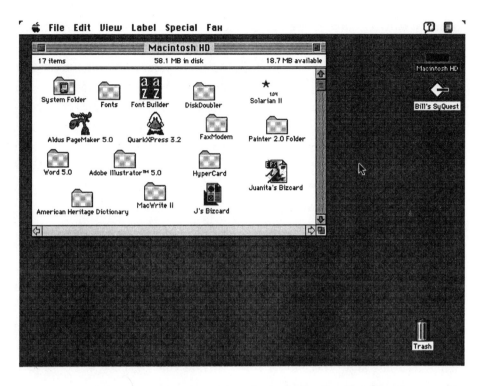

Figure 2-2. The Macintosh Finder displays the Desktop on the monitor screen after the computer has been turned on ("booted-up"). The term "Desktop" refers to the display of icons and windows representing drives, disks, organizing folders, files, and so on.

tions. The look of the graphical interface is characterized by the presence of many graphic images on the computer monitor screen (see Figure 2-2). Most people are charmed by the sometimes whimsical images and processing behavior of the Mac, which, in spite of being a machine, seems to be self-aware.

In DTP, the GUI Rules

The graphical user interface is considered by most people to be easier to learn and use than the character-based interface where commands have

to be memorized and entered in a precise manner with many limitations. In fact, graphics activities such as page layout, illustration, technical drawing, charting, etc. are very difficult, if not impossible, to do on a computer unless it has some kind of graphical interface. Another key factor in the success of the GUI is that it is more intuitive than the linear, character-based interface. Sitting down to a Macintosh with no previous experience may be intimidating to many people, but at least an inexperienced person can usually get immediate responses from the computer. With just a few hours of training most people can begin to achieve quite a lot of success in performing tasks on the Mac.

A Plethora of Macs

Many varieties of Macintosh exist, and more are being marketed each year. Not so long ago there was only one Mac, the familiar little unit with the tiny screen, now called the "Classic." These days, however, there is a Mac for every niche in the market. Electronic prepress work usually demands a fast and powerful machine such as one of the *Quadra* models or the newer *Power Macintosh*.

A Need for Power

The power of a computer is measured by the following criteria: (1) processing speed; (2) RAM capacity; (3) storage memory capacity; and (4) display ability. Processing speed is a key element for graphic designers and other artists because computer graphics can be exceedingly complex and require much processing time. The speed of a computer is determined mainly by its *processing chip,* but other elements, such as RAM and the presence of special processing units, can certainly affect it. For example, a *math co-processor* can not only speed up the computer during some graphics operations, but some special effects filters in Adobe PhotoShop and Adobe Illustrator will not function without it. Processing speed (or *CPU* speed) is measured in *megahertz (MHz),* but this number can be misleading because different processing activities require different amounts of time. Computers are often rated for speed according to benchmark tests

that put the computer through its paces while running specific software applications. Since processing speed is so relative, this is probably the best way to compare computers. In general, though, one can assume that a higher megahertz rating means a faster machine. Typical ratings for top-of-the-line Macs are as follows:

(1) Quadra 610=25MHz;
(2) Quadra 650=33MHz;
(3) Quadra 840AV=40MHz;
(4) Power Macintosh 6100=60MHz;
(5) Power Macintosh 7100=66MHz;
(6) Power Macintosh 8100=80MHz.

The Power Macintosh

Power Macintoshes are the result of an alliance of established leaders in the computer industry—Apple, IBM, and Motorola. The Power Macintosh is the fastest and most versatile Mac yet (see Figure 2-3). It uses a *microprocessing chip* called the PowerPC 601. Previous Macs used Motorola's 680x0 series microprocessing chip, such as the 68040 chip found in the Quadra models. One of the biggest differences between the PowerPC microprocessor and the 680x0 microprocessor is the way they

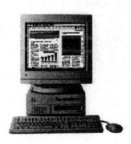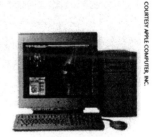

COURTESY APPLE COMPUTER, INC.

Figure 2-3. The newest additions to the Macintosh computer family are (from left) the Power Macintosh 6100/60, the Power Macintosh 7100/66, and the Power Macintosh 8100/80. These RISC-based computers are much faster than their predecessors.

process data. The PowerPC is a *RISC (Reduced Instruction Set Computing)* based processor, and the 680x0 is *CISC (Complex Instruction Set Computing)* based. The RISC architecture has been used for years in *dedicated workstations* and other high-performance computers, but the PowerPC represents the first time it has been available for personal computers. RISC allows much more rapid processing speeds than CISC.

One of the most remarkable aspects of the Power Macintosh is that it can run Microsoft Windows software. Macintosh computers have been able to read DOS-formatted disks and provide a limited DOS work environment for some time, but the Power Mac utilizes a software application called *SoftWindows* to provide a fairly seamless connection between the two platforms. SoftWindows on the Macintosh works exactly like Windows on a DOS-based computer. The SoftWindows software does require that the computer have a fairly large minimum amount of RAM (sixteen megabytes), however.

The IBM PC

One of the most interesting things about the Power Macintosh is that IBM had a hand in its development. It's interesting because IBM was responsible for developing the original PC which was a competitor to the early Macintoshes. The IBM PC was copied, or cloned, by a myriad other companies with the result that IBM did not have full control of the PC market. Macintosh clones have not been marketed in the past, so Apple has always had a unique product. However, the proliferation of inexpensive and well-constructed PCs has had a serious effect on Macintosh sales.

Consequently, Apple is marketing less expensive Macintosh computers to compete with the PCs. The original IBM PC used DOS, as do most of today's other brands of PC, and there are many more PCs in the world than Macintoshes. Still, DOS and the Mac operating system are not in the same ball park, especially in the desktop publishing\electronic prepress field. It was the development of the Windows software by Microsoft that made the IBM PC and its clones viable competitors to the Mac. In fact, Microsoft has become a market giant and no doubt will continue to have a huge impact on personal computing and computer graphics.

Figure 2-4. Microsoft Windows creates a graphical user interface that is similar to the Macintosh GUI. This is a view of the Program Manager where icons for software applications are displayed.

The Windows GUI

The *Microsoft Windows* software creates a graphical user interface that makes a PC behave more like a Macintosh (see Figure 2-4.). So much so, in fact, that Apple brought suit against Microsoft for copying their GUI. It could not be proved that Windows was an attempt to copy the Macintosh operating system, so Apple and Microsoft continue to slug it out in the marketing arena.

The key thing to remember here is that Microsoft Windows is not an operating system. It is software that works with the existing operating system to create a graphical interface. DOS still seems to be the most com-

mon operating system for PCs, but IBM has developed another one named OS/2 (Operating System 2). OS/2 creates its own graphical interface, but it can be used to run a version of Windows.

Microsoft has also developed an operating system for the PC called Windows NT. Both OS/2 and Windows NT are thirty-two-bit operating systems which can take full advantage of today's powerful microprocessors. DOS, on the other hand, is a sixteen-bit operating system which doesn't always fully utilize the potential of the newer computers based on 386, 486, and Pentium chips.

In spite of this, recent tests indicate that standard Windows applications (developed for the sixteen-bit mode) still run best with the Windows/DOS combination. This is logical because OS/2 and Windows NT are not primarily intended to run sixteen-bit Windows software. They both incorporate subsystems which will run Windows software applications, but they were designed to run thirty-two-bit software. Pending the development of thirty-two-bit versions, sixteen-bit software applications such as PageMaker for Windows and QuarkXPress for Windows will probably operate best in the Windows/DOS environment.

Can Windows Do the Job?

Until recently, the Mac has been heavily favored for serious prepress activities, and this may always be the case. However, new developments on the PC side make those machines more and more available for sophisticated prepress activities. Graphics software developers such as Aldus, Adobe, and Quark have modified their products to run in Windows, which has itself become more reliable and sophisticated. New microprocessors for PCs, such as Intel's 486 and Pentium chips, have made those machines faster and faster. Technology is developing so rapidly that change is truly the only constant. The Macintosh may continue to dominate the electronic prepress field, but it would be unwise to ignore or dismiss the PC as a strong prepress platform.

Input Devices

The most familiar *input device* for a computer is the keyboard, but most computers also come with a *mouse*. The mouse is necessary to operate a computer with a graphical user interface. In a GUI, direct commands and other functions are accessed by pointing and clicking with the mouse.

Using a Mouse

In both the Macintosh and Windows environments, commands are located in menus which can be opened by clicking on their titles in the menu bar usually located at the top of the monitor screen. Commands are chosen from menus by pointing to them with the *mouse cursor* (usually an arrowhead) and clicking the *mouse button* (see Figure 2-5). There are other basic mouse-oriented functions such as *scroll bars* and *nudge buttons,* and of course the mouse is necessary for manipulating software tools used to modify elements on the computer screen. Many commands can still be given from the keyboard when using Macintosh and Windows software applications. In fact, it is often faster than using the mouse. It does entail memorization of the commands, however.

There are a variety of mouse designs to choose from. Nearly all computers now come with a mouse, but some people choose to purchase different types. One of the most popular of the "alternate" mouse designs is the *trackball mouse*. A regular mouse is operated by moving it around on the work surface, preferably with a soft rubber pad under it, and clicking the mouse button with the forefinger. A trackball mouse, such as the Kensington Turbo Mouse, remains stationary while a large ball is rolled around with the fingertips to move the mouse cursor. Clicking is done with the thumb. See Figure 2-6. Several variations on the trackball mouse exist, including the built-in trackballs found on laptop computers.

Another input device that is becoming increasingly popular with artists and others who use drawing or painting software applications such as Adobe Illustrator or Fractal Design Painter is the *digitizing tablet*. Also known as a *graphics tablet,* this device allows artists to work on the computer in a more natural way, that is, by holding a pen-like stylus with the

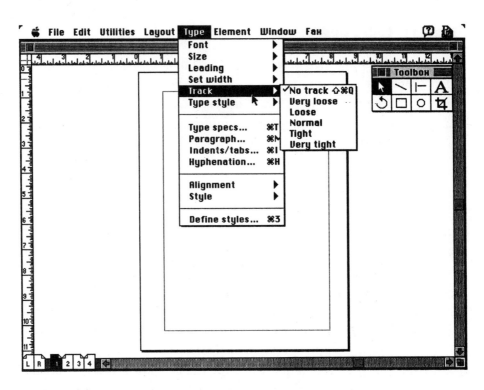

Figure 2-5. In the Macintosh, commands are chosen from a menu by point-
ing and clicking with the mouse. Microsoft Windows offers a similar arrange-
ment. In this PageMaker example, "Track" is chosen in the Type menu to dis-
play a submenu containing the specific typographic tracking commands.

fingers. The stylus is stroked on a special pressure-sensitive pad to create
responses from drawing or painting software tools. The pads usually come
in several sizes. Some models, such as the Wacom UD Series, are cordless
and batteryless and allow two-handed input using the stylus and a special
precision mouse called a cursor.

Monitors

A computer's *monitor,* or display screen, is an important piece of hard-
ware for desktop publishing and electronic prepress. There are two basic
considerations in choosing a monitor for graphics work: size and color

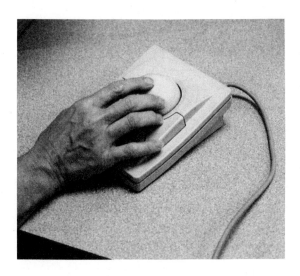

Figure 2-6. The Turbo Mouse by Kensington Microware Ltd. is a popular alternative mouse. An additional button on the right side can be programmed to perform specific functions.

capability. *Resolution* is also important, but you would be unlikely to find a low-resolution monitor being sold today for desktop publishing purposes.

A monitor's resolution is measured by the number of *pixels* (picture elements) present on the screen. Screens with smaller pixels display elements at a higher resolution than screens with larger pixels. The monitor's size affects work habits and overall efficiency during page layout operations. A larger monitor, capable of displaying one or two full eight and one-half by eleven-inch pages, is highly desirable because smaller screens require much zooming in, zooming out, and scrolling to manipulate elements on the electronic page. A monitor's screen is measured diagonally from corner to corner, and twenty- or twenty-one-inch sizes are ideal. Monitors are operated by a special *video card* located in the computer's chassis. These video circuit boards usually contain extra memory (VRAM) for improving the performance of the monitor, especially in the case of color monitors.

It's desirable to have a monitor capable of displaying color, although monitors displaying only tones of gray (grayscale) are sometimes used in desktop publishing. The amount of imaging information a monitor can handle is measured in bits. For example, an eight-bit monitor is capable of displaying 256 colors or levels of gray, but a twenty-four-bit monitor can display more than sixteen million colors. The amount of VRAM present in the video circuit plays a role in the number of colors that can be displayed at one time on a monitor screen.

Data Storage

As electronic prepress software applications have evolved and incorporated more and more sophisticated features, so have hardware technologies evolved to accommodate those improvements. It would be difficult to determine whether one drives the other, for they seem to develop almost in tandem. Whatever the case, more powerful software requires a more powerful computer to operate properly. The most noticeable escalation has been in the minimum amount of RAM required to run such applications as PageMaker, QuarkXPress, Adobe PhotoShop and many others. Almost as noticeable has been the increasing need for larger and larger amounts of storage memory. A full-color *digitized image* can require many megabytes of storage memory, depending on its resolution and other factors.

Floppy Disks, Diskettes, and Hard Disks

The first personal computers relied on three and one-half-inch *diskettes* or five and one-fourth-inch *floppy disks* such as those shown in Figure 2-7, to contain everything, including operating system, software application, and computer files. This sometimes required that the disks be constantly switched while operating the computer—a tedious and frustrating process. Early five and one-quarter-inch floppy disks could contain only 160K of data and the first three and one-half-inch Macintosh diskettes only 200K.

Both types of disks grew in storage capacity, and today a High Density (HD) diskette can contain up to 1.44MB of data. Very High Density (VHD) diskettes that can store larger amounts of data exist but are not very common. The disk material inside the protective cover of a floppy disk or a diskette is polyester plastic coated with a magnetically-sensitive film. Data is encoded on the film by a magnetic head inside the computer's disk drive mechanism. Care must always be taken not to expose diskettes to strong magnetic fields such as airport metal detectors, as this could destroy or corrupt the information stored on the diskette.

As software and operating systems became more robust, the first *hard disks* appeared. These had much more capacity than the floppy disks and diskettes and eliminated the need for switching from disk to disk during

Figure 2-7. five and one-quarter-inch floppy disks (left) and three and one-half-inch diskettes (right) were the first storage memory devices for personal computers.

operations. Everything—operating system, software applications, and files—could be stored more or less permanently on the hard disk.

Hard disks, also referred to as *hard drives*, are classified as internal or external. At first, external hard drives with their own housing and outside cable attachments were more common, but now all microcomputers have internal hard drives. Whether the hard disk is located in its own housing or is contained in the computer's housing, the disk itself is made of a nickel/iron alloy with a magnetic coating similar to that found on a diskette or floppy disk. Data is recorded on it in much the same way also. In the mid 1980s, a twenty-megabyte hard drive was considered a huge amount of storage. Today, anything less than 80 megabytes is considered puny. Some users combine internal and external hard drives to obtain many gigabytes of storage capacity. There are a wide variety of hard drive sizes on the market, and individual needs must be carefully considered when purchasing one. You probably can never have too much memory.

Removable Cartridge Drives

The *removable cartridge drive* has become a popular storage device in desktop publishing/electronic prepress because it is a convenient way to transfer data from place to place. The removable cartridge combines the high-capacity storage of a hard disk with the portability of a diskette, and they have become almost the standard medium for transporting electronic publication files to service bureaus and commercial printers. Small portable

hard drives, or "pocket drives," exist, but the removable drive cartridge developed by SyQuest Technology, Inc. is more widely in use. The SyQuest system consists of an external drive mechanism and a removable plastic cartridge containing the magnetic storage medium (see Figure 2-8). SyQuest cartridges range in storage capacity from forty-four to 270MB. Another type of large-capacity removable disk drive is the *Bernoulli drive,* but it is not as widely used in the electronic prepress field as the SyQuest.

Optical Drives

An *optical drive* uses an erasable optical-magnetic disk which has a glass core coated with a material that is sensitive to both light and magnetism. Because data is transferred to the disk by heating the magnetic material with a laser, an optical disk is more secure than a standard magnetic disk. The data encoded on the disk cannot be altered by an outside magnetic field that might erase or corrupt a regular diskette, hard disk, or cartridge. An optical disk can hold a lot of information for its relatively small size. Optical disks come in five and one-quarter-inch cartridges (600MB) and three and one-half-inch diskettes (128MB). Optical drives are somewhat slower than regular hard drives and are not as widely used.

Back-up and Archival Storage

It's always a good idea to have two copies of all your software applications as well as every file you create on the computer. This is known as *backing-up,* and it protects you from irretrievable loss of data and considerable aggravation in reconstructing and replacing lost computer

Figure 2-8. The removable SyQuest cartridge is a popular and economical way to store and transfer data.

files. Back-up can be done on diskettes or removable cartridges, but the *DAT (digital audio tape) drive* is becoming increasingly popular for individuals and companies requiring large back-up storage capacity. These drives use a tiny (two inch x three inch) cassette that can store as much as ten gigabytes of data. The DAT drive is used for back-up storage because it is too slow to function well as a primary drive.

If data only needs to be stored and not modified, two other devices are available: the *CD-ROM (compact disk-read only memory)* and the *WORM (write once, read many) drive*. Most computer users don't have the means to record information onto compact disks, but they have become a popular means to convey large amounts of information (up to 660 MB) to be read by the computer. The CD-ROM disk is identical to a music CD, but it usually contains much more than music. Graphic images, text, and software applications can be stored on a CD-ROM. This data cannot be changed, and the disk cannot be "written" on by the computer, but CD-ROMs are great for encyclopedias, dictionaries, multimedia presentations and entertainment involving sound, animation and video. CDs are basically a piece of metal foil embedded in a plastic disk. The surface of the foil is stamped to create very small pits that represent data. As the CD is "played," a laser beam is either reflected or dispersed by the surface, creating binary code for the computer to read.

A WORM drive uses an optical disk that is similar to a CD. Data is encoded on the disk with a powerful laser inside the drive. The same laser operating at a lower power reads the information, but it cannot alter it or add more data, hence the name "write once, read many." WORM disks can hold over 600MB, and they are popular for archiving information at many business and government agencies.

Data Transfer and Sharing

The previous section discussed one method for data transfer—putting it on a diskette or removable cartridge to carry it from one location to another. This is humorously known as the *"sneakernet,"* and it represents the most primitive form of *computer network*. Computers are playing an

increasingly important role in our everyday lives, and computer networks are now commonplace as a means of communication.

Networks

Many network consist of computers connected to each other with cables. The computers can then share information through the cables. Small networks such as one might find in a college computer lab or in any company where groups of people share projects are called *local area networks (LANs)*. These networks can be constructed in several ways and have names like *token-ring network* or *bus network*. What all LANs have in common is the presence of a *file server*. The file server is a single computer which controls the network and stores common files. Larger networks are called *wide area networks (WANs)* and often use telephone lines to link computers. The *Internet* is an example of a WAN.

Modems

Another common method for data transfer, or transmission, is *telecommunications*. This relies on a device called a *modem*. The modem connects a computer to a telephone line and sends data over the line to another computer. Modems can be configured as a circuit board inside the computer or as a separate unit outside the computer. Some modems can even function as a FAX machine (FAX modems), sending imaged pages directly from one computer to another computer or FAX machine.

Image Input Devices

In the earlier discussion of traditional and desktop methods for incorporating photographs and other images into publications, this book mentioned that graphic designers and production artists often work with low-resolution placeholder images when constructing an electronic page layout. This is often just a matter of choice for some people, but it also has to do with reproduction quality. If we take for an example one of the most common means to *digitize* an image, a *desktop scanner*, we will find that it is

sometimes used to create the final image, especially when dealing with black and white art or black and white photos. The image quality of a desktop scanner, however, may not be as good as that of the *high-end scanners.*

Desktop Scanners

State-of-the-art desktop scanners are quite capable of creating high-quality black and white and grayscale images. On the other hand, many graphics professionals shy away from trying to create high-quality digitized color images on a desktop scanner. This is where the placeholder image fits in, leaving the final color scanning to a high-end scanner. Actually, it is possible to obtain good color reproduction results using a relatively inexpensive desktop scanner. Some graphics professionals wryly refer to this as "good enough" color, meaning that it is good enough for mundane publications but not adequate for something like a slick "coffee-table" book.

Essentially, the main difference between a desktop scanner and a mid-range or high-end scanner, not considering price, is in the amount of color information that is digitized. A high-end scanner is faster, has more color adjustment functions, and can create higher-resolution images. Desktop scanners are getting better and better, however. These days, quantum leaps in technology are common, and if a prediction can be made based on recent developments, it would be safe to say that high quality digital color will become more and more within the reach of desktop publishers. Resolution and other scanning issues are discussed in Chapter 5.

A scanner digitizes an image into the *binary code* based on 0s and 1s. This technology is similar to that found in an ordinary copying machine where a laser scans the image in horizontal lines at set increments. Scanners can digitize in plain black and white, grayscale, and full color. Most desktop scanners are of the flatbed type where the original art is placed face down on a glass plate, but models also exist for scanning 35mm slides. A scanner may operate in conjunction with a popular image manipulation software application such as Adobe PhotoShop, or it may utilize a specialized scanning software such as Ofoto. Such applications are often sold with the scanner.

Digital Cameras and Video Capture

One of the most exciting new technologies is the development of *digital cameras,* such as the Apple QuickTake, which can be connected directly to a computer to provide high-resolution digital color images. A video camera can also be connected to a computer where its dynamic images can be frozen and captured for use as digitized images. Images can also be captured from a VCR. Video capture requires a special video capture circuit board and software to be installed in the computer.

Photo CD

Kodak's Photo CD is a CD-ROM technology which represents a new standard for digital photo imaging. One of the problems in working with scanned color photographs is the large file size of the images which makes them difficult to store and transport. In Photo CD, a large number of photographs can be scanned and placed on a CD to be accessed by a Macintosh or PC with a Kodak Photo CD compatible CD-ROM drive and the special Photo CD Player software. The process provides convenient and economical access to large file size digital images. The Kodak Picture Exchange is an online service in which end users can access distributors such as stock photo agencies and museum archives to obtain photographic images in the Photo CD format.

Printers

In this book, computer printers are often referred to as "output devices" to distinguish them from other processes, such as offset printing. The term *output devices* can also be used to describe *high-resolution image-setters,* which are in a totally different category from desktop printers such as the laser printer. (See Chapter 3, "Prepress Systems and Service Bureaus.") There are four broad categories of desktop printer: dot-matrix, ink-jet, laser, and color. This discussion is limited to laser and color printers because they are the types most often associated with desktop publishing and electronic prepress activities.

Laser Printers

Laser printers have become a standard tool for desktop publishing because they are capable of higher resolutions and finer print quality than *dot-matrix printers* and *ink-jet printers.* Laser printers utilize a graphics processing unit that interprets data from the computer and renders it as either text or graphics on paper. Otherwise, a laser printer works very much like a laser copier such as the type pioneered by Xerox.

Desktop laser printers are either *PostScript compatible* or *non-PostScript compatible.* The PostScript page-description language enables output devices, such as laser printers, to understand and print complex text and graphic images. Since PostScript has become something of a standard, PostScript laser printers are somewhat more desirable for desktop publishing. The most common laser printers print on eight and one-half by eleven-inch paper at a resolution of 300 or 600 dpi (dots per inch).

Other models can print at resolutions up to 1200 dpi, and utilize twelve by nineteen-inch sheets of paper, allowing full eleven by seventeen-inch *bleeds.* These higher-resolution laser printers make it possible for small-scale desktop publishing operations to obtain output resolution quality that is adequate for most everyday advertising and publishing needs. Black and white laser printers now fill both proofing and final output roles in desktop publishing and electronic prepress activities.

Color Printers

Color printers are also useful for prepress proofing, and in some cases, are even used for final output. It's unlikely that color printer output would be used as a mechanical for making offset printing plates, but it's not uncommon for a color printer to be used like a printing press. In most cases, this would be limited to very *short run printing* needs. "Short run" means that a relatively small number of sheets are being printed. Just how many sheets constitute a short run is entirely open to interpretation. Some commercial printers would consider it to be anything under 5,000 copies; others would say under 500 copies.

Remember the discussion of "comps" in Chapter 1? Color printers have all but replaced the traditional comp because it simply no longer

makes sense to go to all the trouble to construct one. The purpose of a comp is to show as closely as possible how something will actually look when it's printed on a printing press, and a color print can do this much more accurately than a traditional comp.

There are three types of color printers useful in desktop publishing: (1) ink-jet; (2) thermal-wax; and (3) dye-sublimation. Inexpensive color *ink-jet printers,* while adequate for business graphics and other simple color usage, are not really sufficient for prepress proofing. Except in very expensive high-end models, ink-jet colors are often blotchy and don't blend well. *Thermal-wax printers* work very well for comps and prepress proofs because they have brilliant and reasonably accurate colors. Color is applied in a thermal-wax printer as dots of colored wax. The printer contains a roll of plastic film coated with wax-based pigments of each *process color:* cyan, magenta, yellow, and black. As a sheet of paper passes through the printer, the colored wax is melted in dots onto the paper. The paper may make up to four trips through the printing heads to obtain a full-color image, imitating the basic process-color offset printing process. Thermal-wax printers are popular because they use plain paper and are relatively low priced. Prints from these printers usually have a 300 dpi resolution and sometimes lack detail and smooth color gradations.

The best color prints are obtained from *dye-sublimation printers.* They provide photographic quality prints that have sharper details and smoother color gradations than the other types of printers. Mechanically, a dye-sublimation printer works much like a thermal-wax printer. The sheet being printed must pass through the machine up to four times, and color is applied by a heating element that transfers pure cyan, magenta, yellow, and black pigment from a roll of film. The difference occurs in how the pigment behaves. Thermal-wax printers lay down color as individual dots which resemble the dot patterns of *color halftones.* These dots fool the eye into seeing intermediate colors made up of the four basic process colors. In a dye-sub printer, however, the pigments are actually dyes applied to a special coated paper which absorbs the color in a gaseous form. The result is transparent colors which mix on the paper to create a continuous-tone image. Dye-sub printers are more expensive to buy and operate than thermal-wax, and they tend to make smaller text

look fuzzy. Seiko Instruments has marketed a printer which can print in either thermal wax or dye sublimation mode. Tektronix, Inc. (see Figure 2-9) was one of the first developers of desktop color printers and now markets a popular line that includes thermal-wax, dye-sublimation, and ink-jet technologies.

Some electronic prepress futurists say that a color printing revolution is underway with the development of commercially viable *digital color presses*. Evolving both from laser imaging and

PHOTO COURTESY OF TEKTRONIX, INC.

Figure 2-9. Color printers, such as this Tektronix Phaser 220, have evolved into compact units which easily fit on the desktop. The Phaser 220 uses the thermal-wax technology.

offset printing technologies, these machines are reported to provide excellent color reproduction directly from digital graphics files, eliminating the need for film stripping. Some feel that digital printing may replace offset lithography as the fastest, most versatile, and cost effective graphics reproduction method. Only time will tell. See Appendix A for a discussion of digital presses.

A Note on Color Proofing

The use of desktop color printers for proofing is widespread, but it should be remembered that there are higher-quality color proofing standards available through prepress professionals at service bureaus and printing firms. Discrepancies among the various ways color is viewed in the desktop process have always been a problem. A specific color displayed on

a computer monitor will often look entirely different when that color is printed on a color printer. There would probably be differences in the same color printed on different types of printers or even different brands of the same type. Finally, the color may look different when it's actually printed in ink on a printing press. Monitors can be calibrated to more closely match a specific color printer, but monitors display color quite differently from color printers.

The whole issue of color accuracy is receiving a lot of industry attention because it's not only a problem with desktop publishing but has always been a thorn in the side of art directors, designers, and printing industry personnel. ▲

Chapter 2 Review Questions

1. What is the defining feature of the Macintosh operating system?

2. In a GUI, everything is displayed on the computer screen as type
 characters (circle correct answer). True or False?

3. What is one advantage of a graphical user interface?

4. The power of a computer is measured by the following criteria:

 (1)_____

 (2)_____

 (3) _____

 (4) _____.

5. The speed of a computer is measured in (circle correct answer):

 a. Megahertz.

 b. Kilowatts.

 c. Megabytes.

6. The RISC architecture allows a computer to operate faster than

 CISC does (circle correct answer). True or False?

7. The Microsoft Windows GUI is similar to the _____

 operating system.

8. Microsoft Windows is a popular operating system (circle correct

 answer). True or False?

9. The most familiar input device for a computer is the

 _____.

10. A _____ is necessary to operate a computer with

 a graphical user interface.

11. In Microsoft Windows and the Macintosh operating system, many

 commands are located in _____.

12. A more natural way for an artist to work on a computer is with a (circle correct answer):

 a. touch screen.

 b. graphics tablet.

 c. joystick.

13. _____ and _____ are terms used to describe and measure data processing and storage on a computer.

14. The three basic types of computer memory are _____, _____, and _____.

15. A hard drive is used to (circle correct answer):

 a. store data.

 b. contain RAM.

 c. archive computer files.

16. The two basic considerations in choosing a monitor for graphics work are _____ and _____.

17. The removable cartridge drive has become popular for transporting files to a prepress service bureau (circle correct answer). True or False.

18. CD-ROMs are good for (circle correct answer):

 a. backing up computer files.

 b. encyclopedias and dictionaries.

 c. expanding a computer's ROM.

19. Computers can communicate with each other over the telephone lines through a (circle correct answer):

 a. modem.

 b. LAN.

 c. video board.

20. One of the most common means to digitize an image, such as a photograph, is a _____.

21. It's possible to obtain resolutions up to 1200 dpi with a laser printer (circle correct answer). True or False?

22. The best desktop color image quality is obtained with (circle correct answer):

 a. an ink-jet printer.

 b. a thermal-wax printer.

 c. a dye-sublimation printer.

Key Terms from Chapter 2

Apple Macintosh computer
ASCII code
backing-up
Bernoulli drive
binary code
binary process
bit
bleed
bus network
byte
cache memory
CD ROM (compact disk read-only
 memory) drive
CISC (Complex Instruction Set
 Computing)
color halftone
color printer
computer network
CPU
DAT (digital audio tape) drive
dedicated workstation
desktop
desktop scanner
digital camera
digital color press
digitize
digitized image
digitizing tablet (graphics tablet)
diskette
DOS (Disk Operating System)
DOS-based computer
dot-matrix printer
dye-sublimation printer
file server
floppy disk
gigabyte (GB)
GUI (graphical user interface)
hard disk (hard drive)
high-end scanner
high-resolution imagesetter
IBM PC
icon
ink-jet printer
input device
Internet
kilobyte (K)
Kodak Photo CD
laser printer

local area network (LAN)
logic
Macintosh Finder
math co-processor
megabyte (MB)
megahertz (MHz)
microprocessing chip
Microsoft Windows
modem
monitor
mouse
mouse button
mouse cursor
nudge buttons
operating system
optical drive
OS/2 (Operating System 2)
output device
pixel
PostScript compatible
Power Macintosh
process color
processing chip
pull-down menu
Quadra
RAM (random access memory)
removable cartridge drive
resolution
RISC (Reduced Instruction Set
 Computing)
ROM (read-only memory)
scroll bars
short run printing
SIMM (single inline memory module)
sneakernet
SoftWindows
storage memory
telecommunications
thermal-wax printer
token-ring network
trackball mouse
video card
virtual memory
VRAM (video random access memory)
wide area network (WAN)
Windows NT
WORM (write once, ready many) drive

3

When you complete this chapter, you will have learned:

✔ what constitutes high-end and mid-range electronic prepress systems.

✔ how color printing requirements affect electronic prepress systems.

✔ how desktop publishing systems can be linked to high-end electronic prepress systems.

✔ to identify the major electronic prepress vendors.

✔ more about the role of service bureaus in desktop publishing and electronic prepress.

✔ basic information about imagesetters and RIPs.

✔ tips for working successfully with a service bureau.

Electronic Prepress Systems and Service Bureaus

Color Electronic Prepress Systems

Color electronic prepress systems (CEPS), also known as *proprietary systems*, constitute the high-end of electronic prepress. They are expensive, specialized computer-based systems dedicated to scanning, color-adjusting, and color separating full-color *continuous-tone art*. CEPS have been in use for many years and were a replacement for the traditional camera-based method discussed in Chapter 1. They are known as proprietary because each individual vendor's system uses exclusive components that work only on that system.

On the following pages, we will discuss high-end color electronic prepress systems, as well as the increasingly important *mid-range systems* that utilize standard computer platforms (Macintosh, IBM compatible, or Unix-based). As was mentioned at the beginning of Chapter 1, it is becoming increasingly difficult to find significant differences in the three types of systems discussed in this book: desktop, mid-range, and high-end. The industry is still in flux and may remain so well into the 21st century.

The trend seems to be toward fully integrated digital systems that will incorporate all design, prepress, proofing, and output functions, utilizing standard operating systems and *direct-to-film* or *direct-to-plate output devices*. *Direct-to-press systems* and *plateless printing presses* are already

being used, but exactly where the technology will go in the late 1990s is anyone's guess. The future of electronic prepress systems is definitely digital, however.

Although the differences are becoming less and less apparent, CEPS usually differ from desktop and mid-range systems in having greater speed, higher resolution, and better color-processing ability. There is a big difference in the price of the systems. A color house might spend millions of dollars to install a proprietary system as opposed to the mere thousands that a desktop system costs. This high cost and compatibility problems with other systems have led to a downward trend in the installation of high-end color electronic prepress systems. On the other hand, desktop and mid-range solutions are definitely on the rise.

Color Makes It Complicated

Compared to black and white printing, printing in color is a complicated and expensive process. It requires much more skill and craftsmanship. Since color is discussed in Chapter 4, this chapter doesn't go any further into the subject now except to clarify the fact that high-end and mid-range prepress systems are very intensively dedicated to the processes of *color reproduction*. The type of business organization involved in color prepress activities is often known as a *color house*. Color houses (also called *film houses* or *color separators*) employ highly trained personnel who are involved in processing the original art and mechanicals provided by clients who may include advertising agencies, graphic design firms, government agencies, and commercial printing firms. Much of the original art is in the form of color photographs: color prints, 35mm color slides, and four by five-inch color transparencies. Until the 1970s, most of this processing involved the use of the special graphics camera known as a *process camera,* or sometimes as a *reprographic camera*. Because most full color printing requires the use of multiple *printing plates,* the camera produces *film separations* of each color. A color process camera requires great skill and much on-the-job-training to operate well, and still has inherent limitations. In the 1970s, cameras began to be replaced by scanners which could record and reproduce color information electrically.

Today, much of this color separation work is done with a *digital scanner*. At the color house, this scanner may be connected to a proprietary CEPS, or it may be part of a mid-range system based on a Power Macintosh or *Unix workstation*. Although the situation is changing to incorporate the development of new front-end technology (desktop publishing) and new output technology (direct to plate and direct to press), the main purpose of a CEPS is to provide color-separated film ready to be mechanically stripped into flats or the same film electronically stripped and ready to make printing plates.

The High-End Components

In CEPS, a powerful computer workstation is required to rapidly process millions of color pixels. In many high-end systems, these computers use proprietary software which can be used only on the system for which it was designed. Information processed by such computers can require a lot of storage capacity. In early prepress systems, this image data was usually stored on reels of magnetic tape. Today, magnetic hard drives are most often used with tape still being used as a backup medium. Digital audio tape (DAT) will probably be the storage medium of the future due to its large capacity.

The color images that are manipulated in a high-end electronic prepress system come from a scanner. As mentioned in Chapter 2, "Desktop Scanners," a high-end scanner is a much more sophisticated and costly device than a desktop scanner. One of the main differences is the much higher *scanning resolution* that is possible—4,000 to 8,000 dpi, compared to 300 to 1,200 dpi on a desktop scanner.

The *dynamic range* of a high-end scanner is much greater also. This means that it can capture much more detail in the dark and light areas of the original photograph or transparency. Furthermore, high-end scanners can work with larger originals and are much faster. Often a CEPS will include a special low-resolution pre-scan workstation where continuous-tone images can be quickly digitized to measure color density and obtain other imaging information prior to high-resolution scanning. In both pre-scan and final scan devices, the original image is mounted on a plastic

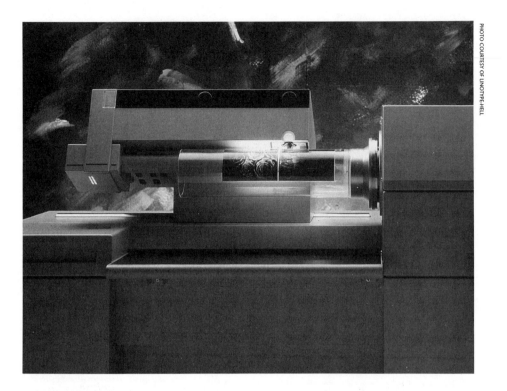

Figure 3-1. The ChromaGraph S3300, a high-resolution drum scanner from Linotype-Hell with a 19.7 x 17.7 inch scanning area, can be fully controlled by a Macintosh computer using the LinoColor 3 color management software. Part of Linotype-Hell's automated ColorPilot system, this scanner is marketed as "the ideal scanner for all shop owners who want to deliver exceptionally high quality to the computer publishing field, but who have little or no knowledge of color reproduction technology."

cylinder, or drum which is then loaded onto the machine (see Figure 3-1). Reflective art, such as color photographs or color illustrations on paper, can be scanned, but color transparencies are preferred.

Transparencies and other original art may be scanned in groups. This is known as *ganging* and is a way to save money on color separations because it's less expensive to scan 5 or 6 images all at once than to scan each one separately. However, ganging on some scanners requires that all the images be sized to the same percentage, and the color content of the

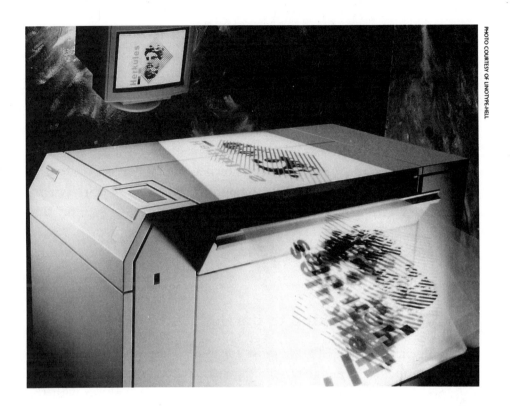

Figure 3-2. The Linotype-Hell Herkules recorder can produce imposed, plate-ready flats from thirty-inch wide film, eliminating the need for traditional stripping procedures.

images must be similar. Recent scanning technology makes it possible to perform multiple-size/multiple-setting scans more economically than in the past.

In a high-end prepress operation, color separations obtained from processing the scanner data are output from a *film recorder*, also sometimes known as a *laser plotter*. These devices differ in mechanical construction from *imagesetters*. They are designed to process film mounted on a drum and are capable of very tight color registration and use very precise *halftone screening algorithms* that are part of the proprietary software. A film recorder is also much faster than an imagesetter. Figure 3-2 shows a film recorder marketed by Linotype-Hell.

CEPS Vendors

Four major vendors of proprietary CEPS are *Linotype-Hell, Scitex America, DuPont Crosfield,* and *Screen.* Hell Graphics Systems, now part of the Linotype-Hell Company, was one of the first to develop the color electronic prepress technology. The complex ChromaGraph DC 3000 system from Linotype-Hell has established a standard of quality and specialization for the industry. Scitex is well known as one of the first to develop a *software link* to connect desktop computers to their proprietary system. Crosfield Electronics is the division of DuPont Imaging Systems that develops high-end prepress systems. Originally the largest prepress vendor in Japan, Screen is now a leading international supplier of many graphic arts products.

Links From the Desktop to the High-End

The benefits of a CEPS are most apparent in the excellence of color reproduction that is possible with expensive, specialized hardware and software. Today, it's possible for desktop publishers to link up with the high-end systems through software links or *gateways.*

In the electronic prepress industry, the Macintosh and PC computers used in desktop publishing are sometimes referred to as *FEPs,* or *front end platforms.* A CEPS can link to a FEP through software applications that connect the two types of systems. These software links are marketed by many high-end prepress vendors. A basic software link converts PostScript data from an electronic page layout produced on a desktop computer into the proprietary CEPS format via a *PostScript RIP (raster image processor).*

Software links such as *ScriptMaster* from Linotype-Hell, *StudioLink* from DuPont Crosfield, *Visionary* and *VIP II* from Scitex America, and *Omega PS* from Screen are used to give desktop graphic designers access to high-end color quality. The process goes something like this:

(1) the designer sends original continuous-tone art (color photos, slides, etc.) to a color trade shop where it is scanned as both high and low-resolution files;

(2) a low-resolution version of the scanned image is sent back to the designer who uses it in the electronic page layout as a *for position only image (FPO)*;

(3) the FPO image can be cropped and masked as dictated by the page design;

(4) the final page layout is transferred to the high-end system through the software link; and,

(5) the low-resolution images are automatically replaced by the high-resolution images.

The benefit of working with low-resolution FPO images is that their smaller file sizes do not overburden the desktop system, causing a slowdown in production. Standards for this image replacement process have been developed by major desktop publishing and electronic prepress vendors. One such standard is the *Open Prepress Interface (OPI)* developed by the Aldus Corporation (now Adobe Systems). OPI is an extension of the PostScript page-description language, and it is supported by many CEPS gateways, including Hell ScriptMaster and Crosfield StudioLink.

Scitex America developed a similar process, *Automatic Picture Replacement (APR)*, in which a low-resolution FPO image is automatically generated when the original art is scanned. Another generic software link from desktop to prepress is the RipLink system from Screaming Technology Inc. RipLink consists of various software modules and provides access to several of the high-end systems.

Hardware links from desktop to high-end also exist. The hardware links are devices which provide a direct connection, or interface, between desktop computers and high-end scanners. While each has unique features, products such as CC Mac from Linotype-Hell, Color GateWay from Associated Graphic Systems, and RipLink Direct from Screaming Technology, all provide such an interface.

Linotype-Hell markets an interesting solution to the desktop publishing/high-end prepress dichotomy: the DaVinci color workstation (see Figure 3-3). DaVinci workstations can accept digital color input from a wide variety of sources, including the Macintosh computer, and can output to any standard PostScript compatible imagesetter, recorder, or print-

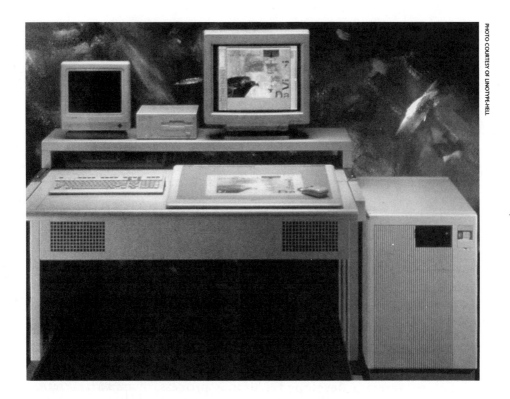

Figure 3-3. The DaVinci color workstation from Linotype-Hell is marketed as a mid-range system which can bridge the gap between desktop publishing systems and proprietary high-end systems.

er. The advantage of the DaVinci system is that it performs complex color operations more efficiently than desktop systems and can more quickly (and less expensively) perform many of the same color and page-assembly functions that are usually reserved for proprietary color systems.

Moving to Mid-Range Systems

Although the prepress industry trend seems to be toward mid-range systems, and service bureaus are utilizing newer and more sophisticated imagesetters that rival high-end output, there may still be times when it's desirable to work with a high-end trade shop. However, it should be

noted that there is plenty of controversy surrounding this concept. Many in the CEPS industry believe that there will always be people willing to pay for ultimate quality, and that high-end prepress technology will be able to stay one jump ahead in terms of quality and speed advantages.

On the other side are the proponents of a total desktop solution to color reproduction. They believe that the CEPS (as we've defined them in this book) are doomed and will give way to desktop solutions due to their cost-effectiveness. These "radicals" point to rapid improvements in desktop color technology—better scanners, sophisticated software solutions to trapping, high-quality color separations, etc.—as evidence that it's only a matter of time until the expensive proprietary systems simply can't compete.

In the meantime, so-called mid-range systems seem to be the answer. Mid-range systems are distinguished by the fact that they fall somewhere between CEPS and desktop systems in quality and speed. They are based on a souped-up desktop computer such as a Macintosh or IBM compatible PC or a UNIX computer such as one of the SUN Microsystems workstations. The key factor in a mid-range system is that it costs a lot less than a high-end system because it is based on a standard computer rather than an exclusive proprietary platform.

A ballpark figure for a complete mid-range system consisting of high-powered computer, scanner, and high-resolution output device would be in the $250,000 range as compared to $800,000 and up for a proprietary system. Utilizing a standard computer such as the Macintosh, standard file formats, and the PostScript page description language, these mid-range systems can provide commercial-quality work rivaling that of the high-end systems. As an alternative to expensive proprietary systems, they might be installed not only at color trade shops, but at commercial printing firms and service bureaus as well. Vendors of high-end systems such as Scitex and Linotype-Hell also offer these mid-range systems. Other mid-range systems are available from Agfa, Eastman Kodak, and Intergraph.

Service Bureaus

This chapter has discussed prepress systems dedicated to full-color printing. However, for many desktop publishers and commercial printers, one-color and two-color printing earns the daily bread. For them, a *service bureau* may be the source of final output to paper or film prior to mass reproduction on a printing press. That is not to say that *process color output* is not possible at a service bureau. As this section illustrates, whether a service bureau can output *color separation film* or not depends on the skill of its employees and the quality of its equipment.

The desktop publishing revolution is responsible for creating a need for service bureaus, and today they are commonplace. In this book, a service bureau is defined as a business which provides various forms of output for computer users. At a service bureau, computer generated publications can be output in paper or film from the high-resolution device known as an imagesetter; business presentations can be output on a film recorder as 35mm transparencies; and color proofs can be output from a color printer or copier.

The imagesetter is a service bureau's main piece of equipment. Just as many service bureaus evolved from typesetting operations, many of today's imagesetters evolved from *phototypesetting* machines. An imagesetter can provide much higher resolutions than a desktop laser printer, and they are much more expensive than a laser printer (over $50,000). Consequently, the service bureau business has flourished by providing affordable, high-resolution output for desktop publishers who require better results than they can get from a laser printer. Some service bureaus also provide other services, such as scanning, image manipulation, file conversion, and page layout.

Designers and others working with desktop publishing technology have begun to take on more responsibility for the entire graphic arts process leading up to mass reproduction. It is in working with a service bureau that issues of responsibility, accuracy, and communication become especially important. This section explores and discusses these issues. Chapter 6 contains a discussion of page layout principles which can expedite the process of working with a service bureau or color house.

Imagesetters

Imagesetters use a photographic process to provide high-resolution image output. A laser beam exposes the images on photosensitive paper or film which is processed in a chemical bath in much the same way that photographs are processed. Essentially, an imagesetter can output the electronic mechanical created in a page layout software application.

Sometimes it's desirable to output the mechanical on paper, especially if any traditional paste-up work is to be done; but if the page layouts have been completed in the computer, many desktop publishers will request output to film instead. The film can be directly used to make printing plates if no stripping and page imposition is required.

It's not uncommon in single-color publications for digital halftones to be embedded in the electronic mechanical, removing the need for any stripping. Some imagesetters can even output on printing plate material. Still, in some cases it's better to take advantage of the traditional stripping process to incorporate halftones or to impose pages for the press. Imagesetters were once used primarily for single-color output, but the newest generations of imagesetters can output accurate color separations for full-color printing.

Two leading vendors of imagesetters are Linotype-Hell and the Agfa Division of Miles Inc. Tegra Varityper, Scitex America, and Optronics are also contenders in the market. In the mid 1980s, the Linotype Corporation (now Linotype-Hell) was the first to exploit the desktop publishing market. Its *Linotronic* brand imagesetters were so common as to make the name "Linotronic" as generic a term as "Kleenix" or "Xerox."

Imagesetters should be thought of as a system of components rather than a single device. It is well to understand the basic workings of the system in order to know what to expect from it and perhaps work more successfully with the service bureau. The three main components of an imagesetter system are: (1) the *raster image processor (RIP)*; (2) the *imager*; and, (3) the *photo processor*.

The Raster Image Processor (RIP)

The RIP can be the most problem-sensitive part of the system. Since it is responsible for interpreting the PostScript data from computer graphics and page layout files, it must process huge amounts of information rapidly and accurately. Extremely large or complicated graphics files can cause problems for the RIP.

The RIP is a computer which converts all the images in a typical publication page—including vector and bitmap illustrations, lines, and type—into a series of pixels which are rendered at the required resolution in the imager. The speed of the RIP is a major concern in the economics of a service bureau because it affects how much data can be processed in a workday and therefore how many clients or jobs can be served. Many generations of RIPs have evolved since the first Linotronic machines—each faster and more sophisticated than the previous.

In some service bureaus, the hardware RIP is being replaced with a software RIP. Software RIPs run on standard computer platforms (Macintosh or IBM compatible), and are considerably less expensive than hardware RIPs, although sometimes not as fast.

Software RIPs can have an impact on desktop computers as well as imagesetters. While most serious desktop publishers use a laser printer with a PostScript RIP built in, some have non-PostScript printers. With a software RIP, such printers can output PostScript graphics and type. Software RIPs can also allow you to output to a variety of color devices such as slide recorders and color copiers. Some of the popular software RIPs are: Freedom of the Press by ColorAge, ZScript by Zenographics, RAMPage by RamPage Systems Inc., and SystemRIP by Zeon.

The Linotype-Hell Company has recently marketed a third type of RIP which is not as expensive as a standalone hardware RIP and faster than a software RIP. Their Vulcan RIPcard is a circuit board that can be plugged into the NuBus slot in a Macintosh. This enables the Mac to function both as a prepress workstation and a RIP station.

The Imager and Processor

The imager, or recorder, is a large machine which records the data from a RIP onto photosensitive RC (resin-coated) paper, film, or printing plate material. The imager uses a laser beam to create tiny *laser spots* (five to thirty microns in diameter) that make up the image on the paper or film. A smaller laser spot creates a sharper-looking image, and this is desirable when *digital halftones* are incorporated in the output.

In digital halftones, the laser spots are grouped together to form the equivalent of *halftone dots*. Some imagesetters are capable of producing color separations using special *frequency modulated (FM) screens*. Also known as *stochastic screening*, this process does not group the laser spots to make halftone dots, but distributes them randomly throughout the image. Frequency modulated screening is discussed further in Chapter 5. Other factors also affect the image quality of color separations. For good color separations, the imager must be able to precisely and consistently place pixels in certain locations on the imaging area.

Once an image has been recorded on the photosensitive paper or film, it must be developed in a photo processor. The final imagesetter processing procedure involves steps that are similar to standard photo processing. The output medium is bathed in a developing fluid which brings up the image; then it is stabilized in a fixing bath. Finally it is washed in water and dried with heat. Because the output medium comes in rolls, finished pages must be cut apart. Proper chemical balance, temperature, and handling are important during the photo processing stage.

Working with a Service Bureau

Electronic publishing technologies and the businesses that support them have developed so rapidly since the 1980s that it has been difficult to establish standards. As a result there has often been a struggle between service bureaus and their clients in allocating responsibility for different aspects of a job. Unfortunately, a major factor in the struggle is a lack of professionalism on the part of those who buy prepress services. The term "professionalism" implies a fully-informed and technically educated state,

in which an individual interacts smoothly and competently with others in a profession. Often, blame laid on a service bureau more properly belongs to the originator of the prepress job.

That is not to say that service bureaus always know what they are doing and never make mistakes. Certainly, some of them are as misinformed and incompetent as some of their clients. However, many problems boil down to poor communication and customer ignorance. The following opening sentences from an amusing article in Publish magazine sums up this point of view: "People expect miracles from service bureaus—bugs to fly away, lines to straighten, dots to disappear, colors to blend. This is a story about the job that didn't print, the customer beyond salvation, and the efforts service bureaus make to salvage often hopeless situations. It is a story of colossal misconceptions, gross misunderstandings, occasional misrepresentations, and the blind faith of the uninitiated. Every good service bureau has seen these jobs and faced these customers—usually in the heat of a deadline. They may be techies, art directors, managers, small business owners, or ordinary folk. They may be you. But they all share some basic misunderstanding of what a service bureau can do. They are 'Clients from Hell.' "[1]

It's the firm opinion of this author that anyone doing desktop publishing has the responsibility of fully informing themselves about the field. That includes knowing how to talk to a service bureau or color house and knowing what to expect under various conditions. A good way to start this education is to sit down and talk to the service bureau's manager. State your expectations and ask for recommendations. Ask that unfamiliar terms be explained; and, if it does not disrupt work flow, ask for a guided tour that explains correct procedures.

A tour may be a lot to ask of a busy and successful service bureau; however, it's not out of line (especially if you are projecting a lot of future business for the bureau). Above all, be aware that this same busy and successful service bureau (or color house) has probably invested thousands (or millions) of dollars in equipment and training to maintain a high level of professionalism. You can best take advantage of their services if you

[1]*Publish, June 1991, "Clients from Hell," Jonathan Littman.*

maintain professionalism as well. For example, always provide a laser printer proof of your page layout or graphics file if you are going for high-resolution output on an imagesetter. This could be a simple cure for the "customer from hell" syndrome because, if your file won't print on a laser printer, it probably won't print on the imagesetter. Other guidelines for expediting your electronic publication through the prepress process are given in Chapter 6 and in the following section of this chapter.

Keys to Success with a Service Bureau

- A good service bureau will have a form to describe services desired by a client. Fill it out completely. Don't make them guess at anything!
- Use mainstream software and make sure the service bureau has the same version that you have. Don't rush into upgrades. Let your service bureau test them first.
- Know what your responsibilities are in regard to *trapping, overprinting, screen rulings,* and so on. You and the service bureau must work together to provide print suppliers with what they need to reproduce the publication on a printing press. Talk to the print supplier before you go to the service bureau to find out what is needed.
- Take to the service bureau all the computer files relevant to the job, but don't take unnecessary files or multiple copies of the same file. For example, provide the originals of graphics files that you have imported into publications created in a page-layout software application.
- List the software that was used to create each file.
- Use the same font technology that the service bureau uses (Adobe Type 1, TrueType, etc.). Adobe Type 1 is the standard.
- Track your revisions carefully. Be sure you send the correct version to the service bureau.
- Delete unused colors, graphics and extra pages from your page layout file.
- Make sure you have at least one backup copy of your files.

Many service bureaus complain of "weird" files that contain a lot of "garbage." Although these terms do not have clear definitions when

applied to desktop publishing, they usually refer to page layout or graphics files which are constructed in an unorthodox or unskillful manner. Output difficulties can arise for many reasons, and in some cases, it's very difficult for a service bureau or trade shop to diagnose the problem. In fact, some desktop computer problems are difficult for anyone to diagnose! The best protection against output problems on the desktop or at a trade shop is a thorough knowledge of software and hardware. Don't be one of those people who says, "I know just enough to be dangerous!" They are the ones who end up with "weird" files. ▲

Chapter 3 Review Questions

1. High-end color electronic prepress systems (CEPS) are also known as proprietary systems because (circle correct answer):

 a. they use exclusive components that are not compatible with other systems.

 b. they are used only by the companies that own them.

 c. they are so expensive.

2. High-end and mid-range electronic prepress systems are intensively dedicated to the processes of _____

 _____.

3. Another name for a color house is _____.

4. Today, most color separations are made on a scanner rather than a process camera (circle correct answer). True or False?

5. Briefly state the main purpose of a CEPS.

6. A high-end scanner is better than a desktop scanner because (circle correct answers):

 a. it has a greater dynamic range.

 b. it provides a higher resolution.

 c. it is faster.

7. One of the four major vendors of CEPS is _____

 _____.

8. Desktop publishing systems can link up with high-end systems through _____.

9. What is an FPO?

10. Two standards for working with FPOs are (circle correct answer):

 a. CEO and VIP.

 b. XYZ and PPD.

 c. OPI and APR.

11. Mid-range systems differ from high-end systems in that they are

 based on a _____

 _____.

12. Mid-range systems are not capable of good color separation work

 (circle correct answer). True or False?

13. A service bureau's main piece of equipment is an

 _____.

14. Many service bureaus evolved from typesetting businesses (circle

 correct answer). True or False?

15. Imagesetters create images by exposing photosensitive paper or film

 to a _____.

16. The component of an imagesetter system that processes PostScript

data in a computer publication file is called the

_____.

17. A small laser beam width in the imager can create poor halftones (circle correct answer). True or False?

18. When working with a service bureau, it's OK to just drop off your disk at the front desk without any instructions because they can usually figure out what you want (circle correct answer). True or False?

Key Terms from Chapter 3

Automatic Picture Replacement (APR)
color electronic prepress system (CEPS)
color house (filmhouse, color separator)
color reproduction
color separation film
continuous-tone art
digital halftone
digital scanner
direct-to-film output
direct-to-plate output
direct-to-press system
DuPont Crosfield
dynamic range
FEP (front-end platform)
film recorder (laser plotter)
film separations
for position only (FPO) image
frequency modulated (FM) screen
ganging
halftone dot
halftone screening algorithm
Hardware link
imager
imagesetter
imagesetter
laser spots
Linotronic

Linotype-Hell
mid-range system
Omega PS (Screen)
Open Prepress Interface (OPI)
overprinting
photo-processor
phototypesetting
plateless printing press
printing plate
process camera (reprographic camera)
process color output
proprietary system
RIP (raster image processor)
scanning resolution
Scitex America
Screen
screen ruling
ScriptMaster (Linotype-Hell)
service bureau
software link (gateway)
stochastic screening
StudioLink (DuPont Crosfield)
trapping
Unix workstation
VIP II (Scitex America)
Visionary (Scitex America)

When you complete this chapter, you will have learned:

✔ the definition of digital color.

✔ the basics of color reproduction.

✔ to identify the various color models and color matching systems.

✔ the purpose of process colors and color separations.

✔ basic information about the problems of color printing, including the need for trapping.

✔ the basics of high fidelity (HiFi) color printing.

✔ why a universal color standard is important.

✔ to better understand the problems involved in human color perception and the calibration of digital color devices.

The Basics of Digital Color and Color Reproduction

Digital Color

Of all the issues deriving from the rapid technological developments in electronic prepress, color is the most important. The primary focus of traditional prepress technology has always been on color printing, and the same is true of electronic prepress technology. *Digital color,* the manipulation of color with scanners, computers, and electronic output devices, is the subject of intense development, and much progress has been made in the first half of the 1990s. As is the case elsewhere in the computer field, new developments in digital color occur quite frequently. This chapter presents information that will help you gain a broad understanding of digital color.

The Basics of Color Reproduction

When you create a publication on a computer, you are starting a process that will lead to its being distributed to and read by other people. That means the publication must be reproduced in quantity, and this is usually done on a commercial printing press. Today, most publications are printed on an *offset press*, where images are transferred from an inked metal or plastic plate to a rubber mat, or *blanket,* and then to the paper.

See Appendix A for a discussion of offset printing and other methods of mass reproduction. Full-color offset printing is a highly developed technology, and the larger printing presses can print up to eight colors of ink on both sides of the paper in one pass through the press.

There are two basic methods for printing color: *spot color* and *process color*. Spot color usually refers to the use of premixed inks. One of the most common types of premixed inks is based on the *Pantone Matching System (PMS)*, in which ink colors are formulated to match industry standards. Hundreds of ink colors can be chosen from a Pantone color formula guide book (a set of color samples bound together and numbered). Spot-color printing with premixed inks usually involves only one, two, or three of these colors being printed. Pantone guide books customarily show the colors printed on both *coated* and *uncoated paper stock* because the paper coating affects how the color is perceived.

Color Matching Systems

The Pantone Matching System is widely used all over the world. Other types of matching systems are available from *Trumatch, Focoltone, Munsell,* and *Toyo*. None of these systems can properly be called color standards, but they are useful for visually matching final printing results to a standard ink color. A true color standard, such as *CIELAB*, is based on the science of *colorimetry* where color is expressed as mathematical formulae. Pantone and the other matching systems exist as a way to specify a certain color for printing with the intention that the printed color would look the same whether it was printed at a "quick-print" shop in Grapevine, Texas, or at a major printing firm in London, England. In reality, of course, factors such as paper stock and ink coverage can affect how well a printed color matches the sample in a color matching guide.

Process Color (CMYK)

Process color refers to the use of four standard printing ink colors: *cyan (C), magenta (M), yellow (Y),* and *black (K)*. Cyan is a medium blue color, and magenta is pinkish red. In process-color printing, dot patterns, or *tint*

screens, of these four colors are printed in different combinations and different percentages. The colored dots are very small and relatively close together, and they combine visually to create hundreds of other colors.

Process-color printing is used whenever color photographs (i.e., *color halftones)* are to be reproduced in a publication. The size of the dots in a color halftone determine to some extent the fidelity of the printed image to the original. Some magazines and books use a very fine screen, and these are often described as "slick." On the other hand, newspapers and other large-volume publications which are printed on relatively inexpensive paper use coarser halftone screens. If your city's newspaper includes a special weekend or Sunday supplement printed in color, you can observe the dot pattern in the color halftones with a low-power magnifying glass.

Although Pantone inks are often used for one and two-color printing, it's not uncommon for them to be used in combination with process colors. The essential difference between Pantone and process color is that hundreds of Pantone colors are available as premixed ink, while process color is the result of combined screen tints of cyan, magenta, yellow, and black. Of course, it's not always necessary to use all four of the process colors to create a desired printing color. (NOTE: Pantone colors are often printed with a screen also, and this creates a tint, or lighter shade, of the solid color.) Because the four process color screens cannot always create the exact color that a designer might wish to use, Pantone colors can be specified to make up the lack. For example, Pantone inks provide fluorescent and metallic colors that would be impossible to achieve with process colors alone. Of course, this adds to the complexity and expense of the printing job.

Specifying Process Colors

In a publication that will use process color to reproduce color halftones, designers will often use the process color screens to create solid or tinted areas of color. Type, lines, background tints, and so on can be printed in color utilizing the same process color screens that are used to reproduce the halftones. There is a difference in these two types of screens, however. The halftone screens use dots of varying size—large dots

Electronic Prepress: A Hands-On Introduction

88 ..

in dark areas and small dots in light areas. The solid areas of color (type, backgrounds, etc.) are printed in *mechanical screens* with dots all the same size. Both types of screens are specified by their *screen ruling,* which is expressed as *lines per inch (lpi).* As was mentioned earlier in this section, the size of the dot has a lot to do with the perceived quality of the printed image. Larger dots (sixty-five lpi) create a coarser image, while smaller dots (133 lpi) create a finer image. Chapter 5 presents more information on halftones.

It has always been difficult to specify the colors to be created with mechanical screens. Because the mechanical-screen process color areas are created by mixing different screen percentages (70 percent cyan, 30 percent magenta, etc.) special process color guides showing all the possible combinations of cyan, magenta, and yellow are used to help make an intelligent decision about screen percentages and combinations. (Process black is often not used in mechanical screen combinations but is used in color halftones to add depth and contrast.) Recent process color guides from Pantone, Trumatch, and Focoltone have made color specification a little easier.

The *Pantone Process Color System* specifies thousands of colors in percentages of CMYK. Many graphics software applications are licensed to use this matching system. The Trumatch and Focoltone color matching systems also provide ways to select and match process colors. The latter two systems are also licensed to be used in leading software applications such as QuarkXPress and PageMaker. The Trumatch system displays more than 2,000 computer-generated colors that specify percentages of CMYK. The mechanical screen tint combinations in the Trumatch system are displayed in 1% increments as opposed to 10 percent increments in many previous types of color guides. Focoltone colors are specified in a range of more than 700 CMYK combinations which contain mechanical screen tints ranging from five to eighty-five percent. With Focoltone, a designer can specify a process color tint screen by choosing from a family of color combinations generated by each of the process colors.

Making Color Separations

Because each color in a publication is applied separately on the printing press, image areas of the same color must be separated from all the other colors to make a printing plate for that color. In the past this was done primarily with a graphics camera that made film negatives for each color. The negatives were then used to make printing plates for each color. This is known as *color separating*. These days, the separating is more likely to occur on a computer. You can use both spot and process colors in a computer-generated publication, and you can output color separations for both.

Spot colors are normally printed as solid areas of ink. Sometimes a tint, or lighter shade of the color is specified, and this translates into a *dot screen* where the number and size of the dots determine how dark or light the tint will be when printed. Process colors, on the other hand, are always printed as dot screens. When you output spot-color separations from your computer, the elements of your page layout will be printed as solids or tints on separate pieces of paper or film—one piece of paper or film for each spot color. When you output process color separations, each process color (cyan, magenta, yellow, or black) appears on a different piece of paper or film as a dot screen. The screens determine how much ink of a given process color will be applied by the printing plate. In a color halftone, larger percentages of a process color create screens with larger dots; smaller percentages create screens with smaller dots. When the dots of color are combined on a printing press, we perceive the results as full color, even though the component dots are various combinations of cyan, magenta, yellow, and black. Page layout software applications such as QuarkXPress and PageMaker can actually output process color separations of Pantone colors by translating a Pantone color into its process color equivalents.

Color Variation in Printing

Although vast effort is expended to make it so, color printing is not an exact science. In addition to the mechanical variables of the printing press, the variable nature of color perception is also a factor. Color is perceived

differently by different people, and it carries an emotional context which must be considered in art and design. Color is dependent on light for its existence, and therefore varies as the light source varies. A color seen in direct sunlight may look quite different when seen under artificial lights.

Our perception of one color is also affected by the presence of adjacent colors. Ink color can vary considerably according to the type of paper on which it is printed. Being transparent, ink color is greatly affected by paper color. The coating and texture of paper affects how ink is absorbed, and this affects the color. The type of press and how it applies ink also has an affect on color printing. A skilled press operator is required to produce a printed piece that matches a standard established by the client. That standard is usually in the form of a *proof.* Various proofing methods exist, and these are discussed in Chapter 6, "Page Layout and Proofing."

Color Trapping

When color separations are made, ink colors can be made to either *overprint* or *knock out* other colors. Overprinting and knocking out are only necessary if colors overlap one another in the design of the publication. A very common example of this is when type is printed in color over a colored background. Overprinting means that the foreground element is simply printed on top of the background element. If the foreground element is printed in black ink, it is usually overprinted. However, if the foreground element is specified to be printed in a color, problems arise due to the transparency of colored ink. For example, printing yellow ink over red ink would mix the two colors to yield orange. This mixing of ink colors on a printing press is extremely difficult to control, and most designers do not attempt it. The solution to the problem is to knock out the background color behind the foreground color. Knocking out can be easily accomplished through any prepress system, including desktop systems.

The registration of the foreground element with the knock-out in the background is a critical issue. Even the best printing presses cannot consistently print the foreground element so that it will fall exactly in the knock-out. The resulting *misregistration* allows the paper to show through on one side of the element. Although the misregistration is usually very

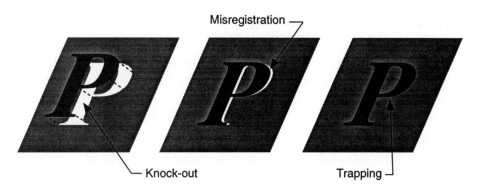

Figure 4-1. To print properly, one color must knock out the color behind it (left). Because of the slight misregistration present on even the best printing presses, gaps may appear along the edges where the two colors are supposed to touch (middle). When this happens, it is necessary to "trap" the two colors by making them overlap just enough to get rid of the gaps (right). The overlaps are created either by spreading the foreground element or choking the knock-out in the background.

slight, it is quite noticeable and is therefore undesirable. To solve the problem, a technique called *trapping* was developed. In trapping, the foreground object overprints around the edges slightly so that the gaps are covered up. This is accomplished through a process of *chokes* and *spreads*.

In choking, the size of the knock-out is decreased. In spreading, the size of the foreground element is increased. See Figure 4-1. Like the knock-outs themselves, trapping can be controlled at the desktop level, but in many cases,it is best left to the experts operating the high-end or mid-range prepress systems. They will probably have access to special trapping software, such as *TrapWise*, which performs the function automatically and with greater accuracy. QuarkXPress does provide built-in trapping features for those who wish to control this prepress function, but it is best to discuss the process with your prepress service provider or commercial printer before attempting it on your own.

High Fidelity Color Printing

High fidelity, or *HiFi, color printing* utilizes seven ink colors to maximize the fidelity of a printed piece to the colors of the original continuous-tone art. HiFi color is sometimes used to reproduce fine art in expensive books and in other situations where the extra cost can be justified. Usually, high fidelity color printing embraces more than just the use of seven colors of ink. It may also include *frequency modulated (FM) screens,* premium papers, varnishes, metallic or fluorescent inks, *laminations,* and special printing techniques such as *gray component replacement (GCR).* Printing in seven inks achieves a larger *color gamut* which cannot be achieved with the four process colors alone. Color gamut is a term used to describe the range of colors that are possible in a device or system. Because of a larger color gamut, HiFi color printing produces brighter color appearance, improved color modulation, and cleaner reds, greens, and blues. There are no fixed standards for the ink colors in HiFi color printing, but cyan, magenta, yellow, red, green, blue, and black are often used.

Color printing is a highly technical field, and it's not within the scope of this book to delve very deeply into the more technical aspects. For example, several methods have been developed to control *ink coverage.* Ink coverage becomes a problem in the darkest areas of an image because there may be 100% of each color ink printing all in the same area. This problem is known as *ink trapping* and refers to the difficulty of printing one ink on top of another. Several methods are used to alleviate the problem of excessive ink: *gray component replacement (GCR), under color removal (UCR),* and *under color addition (UCA).* If you are interested in the technical aspects of color printing, do some research on these terms.

Color Models

Establishing a color standard for the printing industry has always been an important issue. Computer software applications use several *color models* to specify color: the *process color model* (CMYK) mentioned earlier, the *RGB model* (red, green, blue), and the *HSL model* (hue, saturation, light-

ness). There is a variation of the HSL model known as *HSB* (hue, saturation, brightness).

These models are said to be *device-dependent* because they cannot function as universal standards. For example, the RGB model is appropriate for rendering colors on a computer monitor (or television) but does not work for printing. This is because the RGB model is based on a system where each color we perceive is the result of red, green, and blue being mixed as *radiant light*. The RGB model is described as an *additive system* in which mixing red, green, and blue in equal amounts will result in white.

The CMYK model is used for printing inks and is based on a *subtractive system* where mixing equal parts of cyan, magenta, and yellow results in black. In reality, this "black" is more of a dark brown, so a true black is added to the model. (The "K" in CMYK actually stands for "key color.") Two major systems of CMYK or process colors exist: *Euroscale* (in European countries) and *SWOP (Specifications for Web Offset Publications)*. SWOP is the U.S. standard, but printers will tell you that the process color inks vary slightly with different manufacturers.

The HSL or HSB model can be used to describe the basic characteristics of color because hue, saturation, and lightness (or brightness) define the way color appears to us. With the exception of luminous color on a monitor, we perceive colors in terms of the wavelengths of light that are absorbed and reflected by the surface. A white surface reflects all the wavelengths of light while a black surface absorbs them all. Therefore we perceive a single color as reflected light where all the other colors are absorbed. In other words, an object appears red to us if all the other colors of the visible spectrum are absorbed by the object, but red is reflected.

Hue is an expression of the color itself. For example, the color red is a hue. *Saturation* describes the purity of a color, especially when mixed with another color. Decreasing the amount of color in a mix decreases its saturation. *Lightness* and *brightness* are similar terms. It is perhaps best to think of both lightness and brightness as resulting from the amount of white light reflected from the color surface. As lightness or brightness is decreased, the color retains its hue and saturation but becomes darker. Decreasing to zero results in black.

A more recently developed color model is *PhotoYCC* from Eastman Kodak. PhotoYCC was developed for use in the consumer Photo CD system where home photography can be stored on a CD and displayed on a computer equipped with a CD drive. Now that the Photo CD system is having an impact on electronic prepress, this color model is becoming more important. Please see Chapter 5 for more information about using the Photo CD system for scanned images.

A Universal Color Standard

Computers and computer software utilize the color models described above to provide a frame of reference for working with color. The fact that they are device-dependent is an inherent weakness, however. The need for a color model that is independent of any device has long been recognized. Such a system, based on human perception of color rather than on any device, was created in 1931 by the *Commission Internationale de l'Eclairage (CIE)*. The earliest form of this standardized color system was named *CIEXYZ* and was based on virtual primary colors (X,Y, and Z) which do not physically exist. These colors have been contrived on a purely theoretical basis, making them independent of any device or other color model.

Actually, these virtual primaries correspond approximately to the hues red, green, and blue, and they are based on the three color receptors in the human eye. The color receptors differ from person to person, but CIE defines the XYZ color gamut as an average human response to color. The advantage of the CIEXYZ system lies in the fact that its primary colors are designated as fixed coordinates in a numerical system. Therefore, a mathematical basis exists for converting color data from one device to another.

The disadvantage of CIEXYZ is that it's a non-linear measurement system. For example, the visual threshold for a color difference in the green area is much smaller than in the blue area, making it difficult to compare colors. It's like a ruler with a non-linear scale where twice the distance does not mean twice the value. Another system called *CIELAB*

was developed in 1976. CIELAB is based on the original system but incorporates the concepts of hue, saturation, and brightness. CIELAB has the advantage over CIEXYZ in that it is a linear system where colors can be identified as perceptually uniform within the color space.

Color Management

A *device-independent* color standard such as CIELAB is important for desktop publishing and electronic prepress because·color is rendered in so many different ways. Each device (color monitor, scanner, etc.) may present a color in a different way. Colors seen on a monitor are often vastly different from the same colors printed on a sheet of paper. If a universal color standard such as CIEXYZ or CIELAB is used in calculating color conversions between the different components of a digital system, it's possible to factor in the different characteristics of each. Color management involves the translation of color from one component to another. To manage color in a publishing process is to make intelligent decisions about specifying color with predictable results. One of the early buzz words in desktop publishing was *WYSIWYG (what you see is what you get)*. Because WYSIWYG is possible for most elements of a page layout, many people expect it to apply to color as well. However, we must realize that color displayed on a computer monitor will never look exactly like color printed on a sheet of paper, due to the physical differences in the two media. It's up to us as users of the hardware and software to seek solutions and be informed about color technology. One should always remember that the range, or gamut, of colors that we can see is larger than that which can be printed (see Figure 4-2).

Color Calibration and Display

All the devices in the chain of electronic publishing components should be calibrated if color is to be generated and displayed in a consistent manner. In the calibration process, adjustments are made to color settings, and the settings are recorded and held constant. Scanners, monitors,

output devices (printers, imagesetters, etc.), proofing equipment, printing plates, and the printing press itself need to be calibrated to produce consistent colors. A device, such as a scanner, may be self-calibrating. If not, special software can be used to perform the calibration.

In most cases, RGB color must be converted to CMYK color during the digital prepress process. This is a software function, and color-separation programs should be calibrated to perform it correctly. ColorSync from Apple, EfiColor from Electronics for Imaging, and ColorSense from Kodak are three well-known color conversion models.

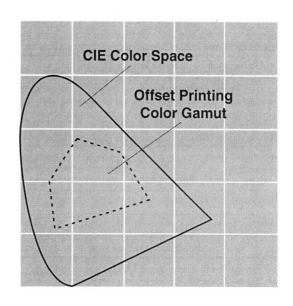

Figure 4-2. This diagram contrasts the CIE color space, which includes all the colors of human perception, with the gamut of colors that can be printed on paper.

When photographs and other continuous-tone art are scanned they become bitmapped graphics files that may be manipulated in many ways on a computer. Each pixel of the bitmap is processed by the computer as one or more bits of information. This is known as the *bit depth,* and the number of bits involved with each pixel has a direct bearing on the way color-bitmapped images are displayed on the monitor. The design of the monitor, system software, and the amount of VRAM determine a computer's ability to display colors and grays.

Simple bitmaps are one bit deep and display only in black and white on any system. Grayscale images are capable of displaying 256 levels of gray but require an eight-bit system to do so. Eight-bit systems can also display 256 different colors. A digitized color image may contain millions

of colors (more, actually, than the human eye can see). A twenty-four-bit system can display over 16.7 million colors, and this is considered ideal for electronic color prepress work.

Of course, the bits per pixel information is determined when the image is scanned, and it is possible to display a twenty-four-bit image on an eight-bit system. This is done by *indexing* the colors. If a color image is indexed, 256 of the most frequently occurring colors in the twenty-four-bit file are used to make an eight-bit version. In a sixteen-bit system, the indexing process can display over 65,000 of the millions of colors in a 24-bit file. An indexed image can look almost as good as the original due to the limitations of the human eye. ▲

Chapter 4 Review Questions

1. The primary focus of electronic prepress technology is on

 _____.

2. What is digital color?

3. The two basic methods for printing color are

 _____ and

 _____.

4. A color matching system such as Pantone is useful for (circle correct
 answer):

 a. calibrating a color monitor.

 b. matching printed color to a standard ink color.

 c. matching color on the monitor to printed color.

5. Name the four standard process colors.

6. Process color printing is used whenever color photographs are included in the publication (circle correct answer). True or False?

7. Process colors and Pantone colors are never used at the same time in a printing job (circle correct answer). True or False?

8. In Process color printing, color images are created by (circle correct answer):

 a. halftone screens of each process color.

 b. mixing colors in a color model.

 c. using higher screen frequencies.

9. Black is used in color halftones to add _____ and

 _____.

10. Color separations are necessary because printing presses must apply each color of ink separately (circle correct answer). True or False?

11. Before electronic methods were developed, color separations were made with a camera (circle correct answer): True or False?

12. Because they are transparent, ink colors are affected by

when they are printed.

13. When colors overlap each other in a printed piece, the foreground color can either _____ or

_____ the background color.

14. Trapping is necessary to compensate for (circle correct answer):

 a. misregistration in the printing process.

 b. poor ink coverage.

 c. too many ink colors.

15. Trapping is accomplished through _____ and

_____.

16. High fidelity color printing involves the use of more than four colors of ink (circle correct answer). True or False?

17. What is a color gamut?

18. The RGB color model is described as an

 _____ system.

19. The CMYK model is a _____ system.

20. What is a hue?

21. The color model developed by Eastman Kodak for use in the Photo
 CD system is known as _____.

22. CIE is an acronym for the (circle correct answer):

 a. Color Institute of Europe.

 b. Commission Internationale de l'Eclairage.

 c. Color Intervals for Emulation.

23. CIELAB is a device-dependent color model (circle correct answer).

 True or False?

24. Why is a universal color standard desirable?

25. Bit depth describes the (circle correct answer):

 a. height of a pixel.

 b. number of pixels that can be stacked up.

 c. number of bits in a pixel.

Key Terms from Chapter 4

additive system
Aldus TrapWise
bit depth
blanket
choke
CIELAB
CIEXYZ
CMYK (cyan, magenta, yellow, black)
coated and uncoated paper stock
color calibration
color gamut
color halftone
color models
color separating
colorimetry
Commission Internationale de l'Eclairage
 (CIE)
device-dependent
device-independent
digital color
dot screen
Focoltone
frequency modulated (FM) screen
gray component replacement (GCR)
high fidelity (HiFi) color printing
HSB model
HSL model
hue
indexing colors
ink coverage
ink trapping

knock out
lamination
lightness (brightness)
lines per inch (lpi)
mechanical screens
misregistration
Munsell
offset press
overprint
Pantone Matching System (PMS)
Pantone Process Color System
photoYCC
process color model
proof
radiant light
RGB model
saturation
screen ruling
spot color
spread
subtractive system
SWOP (Specifications for Web Offset
 Publications)
tint screen
Toyo
trapping
Trumatch
under color addition (UCA)
under color removal (UCR)
WYSIWYG

5

When you complete this chapter, you will have learned:

✔ the characteristics of a scanned image.

✔ why resolution is important and how to calculate the optimal resolution for scanning an image.

✔ how the Kodak Photo CD System works.

✔ to identify various image manipulation software tools.

✔ the purpose of halftoning and how digital halftones are created.

✔ the importance of the screen frequency/output resolution relationship.

✔ more about the role of frequency modulated (FM) screens and how they are created.

Scanning and Image Manipulation

Creating Digital Images

This book has touched upon the *scanning* process and the creation of *digital halftones*. This chapter takes a closer look at the scanned images themselves and discusses important factors which determine image quality. It also gets more deeply into how digital halftones are made, and discusses the factors affecting their quality.

Understanding scanning and digital imaging is important to gaining an understanding of the whole field of electronic prepress because scanning bridges the gap between what we see in the real world and what we see through the computer. By *digitizing* an image into groupings of bits, a scanner produces data that a computer can manipulate.

Perhaps the most important factor in scanning an image is the quality of the original and the ability of the scanner to duplicate it. A poor original usually produces a poor scan and a poor image. A bad scan of a good original also produces a poor image. Digital image manipulation software, though sophisticated, cannot make a good image out of a bad one. Of course, the qualities of "good" and "bad" are not precise terms and are open to interpretation; however, it should be remembered that the scanner

produces all the data that a computer will have to work with. Therefore, it's worth extra effort to obtain the best possible scan of an image.

A good scanner should produce a broad *dynamic range* and a sharp image. It should be able to perform efficiently and quickly with the least amount of manual adjustment, and it should produce consistent results scan after scan. Dynamic range refers to the ability to distinguish detail in both dark and light areas of an image and to discern differences between colors that are close together in value.

The different types of scanners range from simple hand-held models to complex high-end drum scanners. Inexpensive color desktop scanners are commonplace today and are capable of producing good images, but the best digital images come from the high-end scanners. Please remember as you read this chapter that the terms, *scanned image* and *digitized image* can be used interchangeably.

The Question of Resolution

Resolution is one of the most important factors in scanning, but it's often the least understood. Resolution is commonly expressed as *dots per inch (dpi)*, but *pixels per inch (ppi)* is more accurate. In this chapter, we will use pixels per inch to avoid confusion with the term "dots" as used in halftones.

It is important to clarify the term, "resolution." Resolution always refers to the number of pixels per unit of linear measurement (usually inches or centimeters). It is not used to define file size or image area, although it's certainly related to them both. Resolution is set when the image is scanned, and this establishes a file size for the image. If the resolution is changed after an image is scanned, the area of the image will get larger or smaller, but the file size will remain the same as long as the number of pixels per inch remains the same. Reducing the resolution results in a larger image area; increasing the resolution results in a smaller image area.

Although it is possible to change the number of pixels (thereby changing the file size), the resulting image is not quite as good as one which retains the original number of pixels. In other words, it's better to scan an

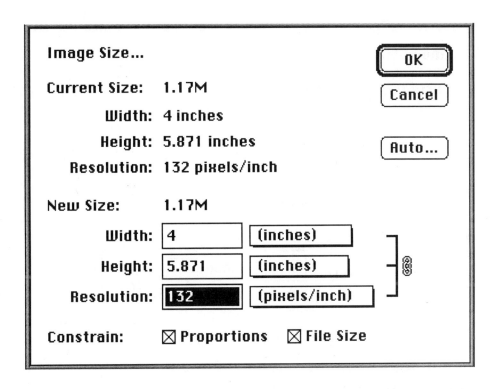

Figure 5-1. This example of the "Image Size" dialog box in Adobe PhotoShop shows that an image has been scanned at a resolution of 132 pixels per inch. The image is four inches wide by 5.871 inches tall, and it has a file size of 1.17 megabytes. Notice that proportions and file size constraints are enabled (bottom of dialog box).

image at the correct resolution than to alter the resolution after the scan. Figures 5-1, 5-2, and 5-3 show a dialog box from Adobe PhotoShop where image area, resolution, and file size are altered.

Determining the Scanning Resolution

A simple formula exists for determining the best scanning resolution. Simply multiply the output *line screen frequency (lpi)* by two. For example, if you were designing magazine page layouts, it's likely that you would specify 133 lpi for all halftone screens. This is a relatively fine screen, and

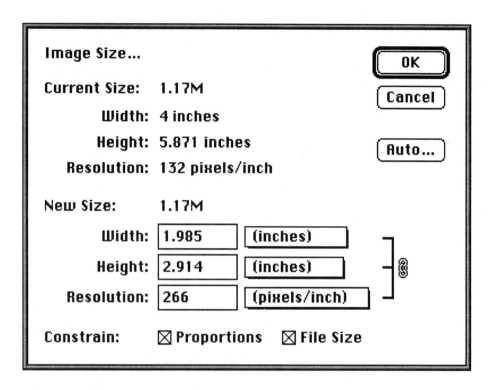

Figure 5-2. In this example the resolution of the image has been increased to 266 pixels per inch. Notice that image area has decreased to 1.985 x 2.914 inches, but the original file size of 1.17 megabytes has remained the same.

it produces printed images with good detail and a wide range of tonal values. Using the formula, 2 x 133 = 266, gives us an optimal scanning resolution of 266 ppi. Smaller multipliers, such as 1.5, may be used, but a scanning resolution that is too small for the line screen frequency will result in poor image quality.

If the image must be reduced or enlarged (scaled) to fit the layout, it should be done with the scanning software rather than after the image is imported into a page layout software application. As we see in Figures 5-1, 5-2, and 5-3, *image resolution, image area,* and *image file size* are interrelated.

Image Size...

OK

Cancel

Current Size: 1.17M

Width: 4 inches

Height: 5.871 inches

Auto...

Resolution: 132 pixels/inch

New Size: 4.76M

Width: 4 | (inches)

Height: 5.871 | (inches)

Resolution: 266 | (pixels/inch)

Constrain: ☒ Proportions ☐ File Size

Figure 5-3. Now the example shows the same increase in resolution (from 132 ppi to 266 ppi) with the file size constraint removed. The image area did not get smaller as it did in Figure 5-2 because new pixels were formed by the PhotoShop software. Notice that the creation of new pixels has increased the file size from 1.17 megabytes to 4.76 megabytes. The new pixels are created from an analysis of existing pixels. The image quality would be better if the image had been originally scanned at 266 ppi.

If you enlarge a scanned image, more pixels are needed to maintain image quality, and the image file size must increase. Conversely, if you reduce an image, pixels must be discarded or consolidated, and the image file size decreases. Calculating the best scanning resolution under these conditions is a little more complicated than simply multiplying the line screen frequency.

To calculate the best scanning resolution when an image is to be scaled, use the following formula: divide the new size by the original size,

multiply the result by two, then multiply again by the line screen frequency. For example. a four by five-inch transparency that must be enlarged to six inches wide and output at 133 lpi would need the following calculation: $6 \div 4 \times 2 \times 133 = 399$. The scanning resolution can be rounded off to 400 ppi.

The Kodak Photo CD System

Because desktop color scanning doesn't always produce color images of adequate quality for some "slick" publications, professional graphic designers may turn to a color house for scanning and other prepress services. In fact, some designers limit their desktop scanning to the creation of *for position-only (FPO)* images that are used primarily as an aid to the graphic design and page layout process. They may also use a scanner to digitize black and white art, either for the purpose of including it in the final layout or for use as a template in a PostScript drawing program such as Adobe Illustrator. An alternative to both desktop scanning and high-end scanning is the *Kodak Photo CD System* that was mentioned in Chapter 2. You can take your color images to a professional photo lab that has access to the Kodak system and receive scanned versions stored on a CD in five different resolutions. The image quality is comparable to that of mid-range scanners. The process is efficient and cost-effective and is gaining in popularity.

Another aspect of Kodak's involvement in electronic prepress can be seen in the development of a color separation file format that can be shared among color electronic prepress systems (CEPS) from different manufacturers. Kodak worked with Crosfield, Dainippon Screen, Linotype-Hell, and Scitex to develop a common CMYK file format called *TIFF/IT (Tag Image File Format for Image Technology)*. This standard format is part of an overall system called *Print Photo CD*. The Print Photo CD system allows scanned images and page layout files to be stored on a Photo CD which is used as the transfer medium between a color house and its clients. In that sense, the system performs in much the same way as a software link. After high resolution scans are merged with the page lay-

outs, the Print Photo CD can be used in any CEPS to perform digital stripping and proofing procedures.

Image Manipulation

After an image has been digitized, the pixels can be manipulated with an *image editing software application*. The widespread use of Adobe PhotoShop has made it almost a standard for desktop image manipulation. For the sake of discussion, we will categorize image manipulation into two types: *image enhancement* and *special effects*.

Image Enhancement

Even when starting with an ideal image, some minor corrections may be needed after the image is digitized. *Tone correction, color correction,* and *sharpening* are sometimes performed to improve the way an image looks. Tone correction may be needed to change the distribution of lights and darks in a *grayscale* or color image. The tonal distribution of an image is described in a special graph called a *histogram* (see Figure 5-4). In Adobe PhotoShop, the distribution of tones can be altered by making adjustments in the "Curve" dialog box. Changing the path of the curve changes the values in the image as shown in Figures 5-5 and 5-6. The "Levels" dialog box shows the histogram graph. Note the differences in the histograms in Figures 5-4, 5-5, and 5-6. The histogram shows the actual tone distribution of an image with dark tones on the left and light tones on the right. The peaks and valleys indicate the number of pixels present for each tonal value in an image.

In addition to grayscale corrections, color corrections are sometimes necessary to make an image look more like the original, but a designer's creative sensibilities may also dictate color changes in the image. High-end scanners are sophisticated enough to perform all necessary color corrections automatically, but colors can be adjusted in image manipulation software as well. In PhotoShop, for example, color corrections can be made by adjusting shadows, midtones, and highlights in either the RGB or

Figure 5-4. The tonal values (256 levels of gray) of the scanned image in the upper right are unaltered as indicated by the straight diagonal line in the "Curve" dialog box (top left). The histogram in the "Levels" dialog box (bottom) shows a fairly even distribution of pixels representing darks and lights. The peak on the left indicates a concentration of very dark pixels. The peak on the right indicates a larger concentration of pixels representing middle-light tones.

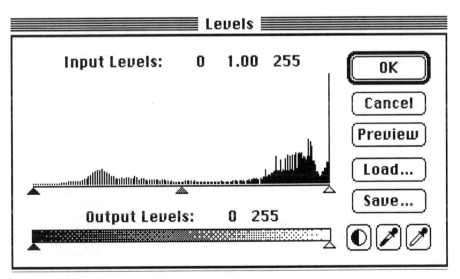

Figure 5-5. The same image from Figure 5-4 (upper right) has been light-ened overall by manipulating the curve downward in the "Curve" dialog box (upper left). The histogram in the "Levels" dialog box (bottom) indicates a concentration of light pixels on the right side of the graph.

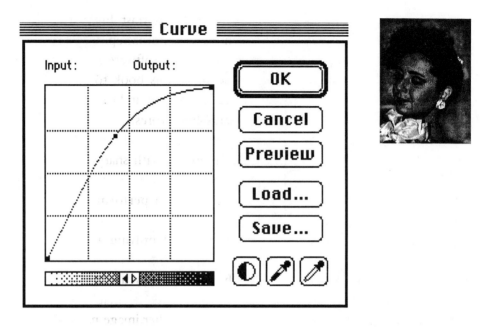

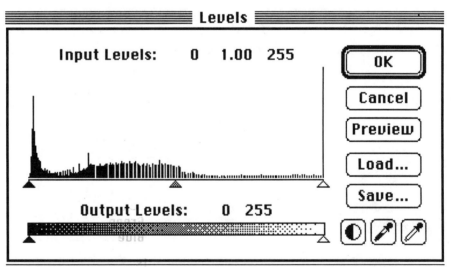

Figure 5-6. The image from Figure 5-4 (upper right) has been darkened overall by manipulating the curve upward in the "Curve" dialog box (upper left). The histogram in the "Levels" dialog box (bottom) indicates a concentration of dark pixels on the left side of the graph.

CMYK color model (see Figure 5-7). Brightness, contrast, hue, saturation, and lightness can also be manipulated in Adobe PhotoShop. Color adjustment in PhotoShop and other image manipulation software applications is a complex subject that is beyond the scope of this book to cover thoroughly. Many good books on the subject are in print and can be found in the computer graphics section of most large bookstores.

If a scanned image lacks the definition of detail and sharpness of the original continuous-tone art, it can be improved with sharpening filters. The better scanners can automatically sharpen an image to compensate for inevitable loss of detail, but sharpening is often performed in image manipulation software. In PhotoShop, the "Sharpen," "Sharpen More," and "Unsharp Mask" filters increase detail by identifying and adjusting certain pixels.

Special effects can drastically change the way an image looks. Sometimes a rather uninteresting image can be made fascinating by applying a special effects filter in PhotoShop or some other image manipulation software. Special effects can distort an image beyond recognition and should be used with discretion. Much trial and error is usually necessary to arrive at a usable image. Figure 5-8 shows a basic image and three versions with special effects applied in Adobe PhotoShop.

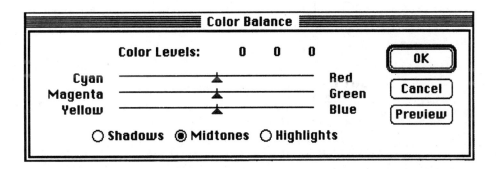

Figure 5-7. The "Color Balance" dialog box in Adobe PhotoShop allows color levels to be changed by sliding the triangular handles to the left or right. Colors can also be adjusted in the "Levels" dialog box and the "Curve" dialog box.

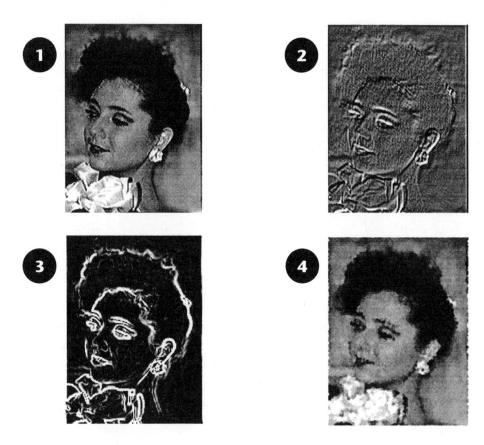

Figure 5-8. Number one is a basic grayscale image with the "Sharpen Edges" filter applied. Number two has the "Emboss" filter applied. Number three was altered with the "Find Edges" filter, and number four shows the effects of the "Crystallize" filter.

More About Halftones

This book has touched on the subject of *halftones* several times in other chapters, and now it's time to take a closer look. An understanding of scanning and digital imaging cannot be complete without some knowledge of the basic principles of halftoning, especially *digital halftoning*. The reproduction of photographs is a major factor in almost all commercial printing, and photographs, as well as other continuous-tone art,

cannot be printed on a printing press unless they are converted to halftones. In fact, halftoning is not just limited to photographs. In black and white printing, any printed area of gray is the result of halftoning. Color tints in full-color printing are often created with halftone screens.

A halftone gives the illusion of continuous tones of gray or color by rendering an image as dots which combine visually into the various tonal values. The dots are usually referred to as a *halftone screen*. The dots in halftone screens vary in size, depending on how dark or light the tonal value. Smaller dots are used in light areas, and larger dots in dark areas (see Figure 5-9).

The dots are always spaced evenly on the screen. The size of the dot is also directly related to the *screen frequency* (or *ruling*), expressed as *lines per inch (lpi)*. The term *line screen* is used to refer to the screen frequency: sixty-five-line screen, 133-line screen, and so on. A higher screen frequency number means there are more halftone dots per inch, and a lower number means there are fewer. As we mentioned in the color chapter, the higher the screen frequency of a printed halftone, the better it reproduces the detail and/or color of the original (see Figure 5-10). Newspapers print halftones with screen frequencies from sixty-five lpi to one-hundred lpi. Magazines use 120-, 133-, or 150-line screens, and a high-quality art book might be printed with 200-line screens or higher.

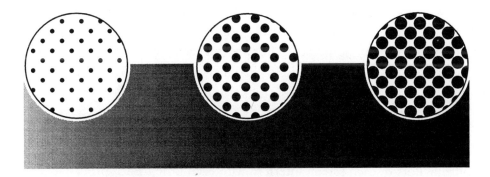

Figure 5-9. A halftone creates the illusion of continuous tones of gray or color. Lighter areas of an image contain smaller dots; darker areas contain larger dots.

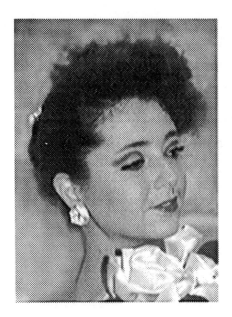

Figure 5-10. Halftones are specified in lines per inch (lpi) which indicates the number of dots per linear inch. A sixty-five-line screen (left) appears coarser and may lack definition of detail. A good eye can discern the individual dots without magnification. A 120-line screen (right) renders detail better, and the individual dots can only be seen when the image is magnified.

Other factors which affect halftones are *screen angle* and *dot shape*. Black and white halftones are usually printed with the dots running at a forty-five-degree angle because over the years this has proven to be the most satisfactory. Screen angle is extremely important in process-color printing because the process color screens overlap each other to build up the illusion of a full-color image. The overlapping halftone screens (one for each color: cyan, magenta, yellow, and black) can create an unwanted secondary pattern called a *moiré*. The moiré pattern occurs when the halftone dots of each screen interfere with each other. Each process-color screen must be precisely positioned at an angle to the others to prevent moiré patterns. For example, traditional, or photomechanical, color halftone screen angles are: 105 degrees for cyan, seventy-five degrees for

magenta, ninety degrees for yellow, and forty-five degrees for black. These screen angles do not always work well for digital color halftones, however; so other angles may have to be worked out for halftones created on imagesetters and film recorders.

Halftone dot shape is primarily an aesthetic consideration. Traditional halftone dots are often round, but digital halftones may have round, elliptical, square, or cross-shaped dots. Sometimes dots are not used at all. In both traditional and digital halftones, lines may be substituted for dots to create an aesthetic effect (see Figure 5-11).

A halftoned photograph can never be quite as good as the original, but it can come close—especially with some of the newer screen technologies. Traditional halftones are made with a graphics camera by photographing the original art through a special etched

Figure 5-11. A halftone screen made of lines can produce an interesting effect. In this example, a thirty-five-line screen and ninety-degree angle were specified to enhance the effect.

glass screen which breaks up the image into dots of varying sizes. The size of each halftone dot is determined by the amount of light transmitted through the halftone screen. Lighter areas on the original create smaller dots; darker areas create larger dots. Electronic prepress technology has introduced digital halftones, which are created quite differently.

Scanning for Digital Halftones

A scanner digitizes an image by creating pixels which contain varying amounts of tonal information in the form of bits. The amount of information is expressed as *pixel depth*. Scanners use a computer chip which contains an array of elements called a *charge-coupled device (CCD)*. The CCD

array converts light energy (photons) into electrical energy (electrons) to create a bitmapped computer file which displays as pixels on the computer monitor.

To obtain good digital halftones, a scanner must store multiple bits of information in each pixel. Black and white continuous-tone images such as photographs require eight bits per pixel to be digitized as grayscale images in which each pixel can be any one of 256 shades of gray—the maximum number of gray levels that the PostScript page description language can support.

High quality digital color images require twenty-four bits per pixel, providing a possible 16.7 million colors. Twenty-four-bit color is the result of multiplying the 256 shades within each of the three colors (red, green, blue) in the additive color system (256 x 256 x 256 = 16,777,216).

Creating Digital Halftones

To output digital halftone images on a laser printer, imagesetter, or other prepress output device, the pixel information in a grayscale image must be converted to some kind of clearly defined dot or spot. The digital halftone mimics the traditional halftone in that it is made up of dots lined up on a grid where the dots are equidistant from each other. The way the dots are made is quite different, however, and there are additional differences in terminology. In fact, the terminology is quite confusing, and the word "dot" is the worst culprit.

The term is appropriate for traditional, or photomechanical, halftones, but can be used to mean something else entirely when applied to digital images. Not surprisingly, there is disagreement among experts; "dot" is sometimes used in describing digital halftones but the term "spot" is also used. Additionally, "dot" is used when referring to the output of laser printers and imagesetter—300 dots per inch, 2,540 dots per inch, and so on.

Imagesetter manufacturers refer to *laser "spots"* as the smallest mark that an imagesetter can make. These are also referred to as *machine spots*. Much of the confusion seems to derive from this ambiguity. This book will not try to resolve the issue, but will simply stick to consistent usage,

referring to traditional halftones as "dots." (The dots per inch designation of a laser printer or imagesetter refers to the resolution of the device itself rather than to halftones.)

Because it is made up of multiple machine spots that are grouped together into a unit, the digital halftone "dot" is referred to in this book as a "cell." Finally, the word "spot" is always used in this book to conform to the laser spot/machine spot definition mentioned earlier. Even the term "pixel" suffers from ambiguity, sometimes being confused with "dot" and "spot." In this book, pixel is used exclusively to designate the elements that make up a digital image before it is output. Pixel means "picture element" and is also used to describe the resolution of an image, as in pixels per inch (ppi). To recap might be helpful at this point:

- traditional halftone "dots;"
- digital halftone "cells;"
- laser or machine "spots;"
- computer image "pixels."

The Screen Frequency/Output Resolution Relationship

In a digital halftone, each cell (the digital equivalent of a photomechanical halftone dot) is created in an imagesetter by grouping together laser spots (see Figure 5-12). The size of these cells varies according to specifications for screen frequency and the tonal value of that area of the halftoned image. The number of laser spots in a cell is determined by the output resolution. The cells can display different amounts of gray or color (up to 256 levels), and this is determined by the number and size of laser spots in the cell. First, an image must be scanned at an appropriate resolution to provide the gray or color level information that will go into making the halftone cells. As discussed earlier in this chapter, a scanning resolution is directly related to the screen frequency of the output device. (Remember the two x screen frequency formula?) Assuming the image has been digitized properly, the choice of output device will determine how well the digital halftone can reproduce the gray or color tonal values of the original. A low-resolution output device, such as a 300 dpi laser printer, can actually make a better looking halftone at its fifty-three lpi default

Electronic Prepress: A Hands-On Introduction

122 ...

Figure 5-12. In a digital halftone, each cell (equivalent to a photomechanical halftone dot) is composed of laser (machine) spots generated in the output device.

than it can if a higher number is specified. This is because it requires larger halftone cells to display an adequate number of gray levels, and lower screen frequencies allow larger cells.

The problem with such images, though, is that they are really too coarse to show much detail. Higher-resolution laser printers can make slightly better halftones, but most graphics professionals choose the high-resolution imagesetters for final output. Imagesetters with output resolutions of 1200, 2400, and higher can provide much higher screen frequencies, and, because their laser spots are smaller, can fit more levels of gray into each halftone cell.

Digital halftone cells are not perfect replicas of traditional halftone dots, for they may not be perfectly round (or elliptical). Early attempts at digital halftoning produced poor results, but much progress has been made, so that today we can obtain excellent halftones from digital equipment. Digital color halftones were particularly inadequate in the early days of electronic prepress due to difficulties in working with precise screen angles, usually resulting in uncontrollable moiré patterns. Today, better digital halftone systems known in the industry as *supercell technology* have helped to solve the problem. Adobe Accurate Screening, Agfa Balanced Screening (ABS), HQS Screening from Linotype-Hell, and ESCOR from Varityper are some popular supercell technologies.

No More Halftones?

Chapter 4 mentioned *frequency modulated (FM) screens* in connection with high fidelity color printing. FM screens are an interesting alternative to digital halftone screens, although it's doubtful that this relatively new technology will totally replace the old one any time soon. Frequency

modulated screen technology has been around since the early 1980s and is also known as *stochastic screening* or *random screening*. Leading prepress industry vendors have developed stochastic screening technologies. There is Cristal-Raster from Agfa, Diamond screening from Linotype-Hell, and FULLtone from Scitex. To create regular digital halftones, an image-setter must group laser spots together to form halftone cells that emulate traditional halftone dots. In FM screening, the image-setter places laser spots randomly in the image area, building up a printable image that has more detail and a larger color gamut than is possible with halftone screens. The difference between the two types of screens is readily apparent in Figure 5-13.

Regular halftone screens and frequency modulated screens are analogous to *AM (amplitude modulated)* and *FM (frequency modulated)* radio waves. As shown in Figure 5-14, AM radio waves maintain a constant distance (frequency) from peak to peak, but the height of the waves (amplitude) changes. FM radio waves maintain a constant height, but the distance from peak to peak changes.

Figure 5-13. The cells in a digital halftone (top) are spaced evenly and are equidistant from each other. The cells are composed of grouped laser spots. A frequency modulated screen (bottom) contains randomly placed laser spots. (These examples are conceptual drawings of highly magnified screens.)

COURTESY LINOTYPE-HELL

Figure 5-14. An amplitude modulated (AM) radio wave (left) and a frequency modulated (FM) wave (right). The amplitude change in an AM wave can be compared to halftone cell size: the higher the wave, the larger the cell size. The frequency is comparable to line-screen ruling (lpi).

In frequency modulated screening, screen angle and screen ruling are no longer relevant, and this is its greatest advantage. Moiré patterns are eliminated and it's much easier to print more than four colors of ink (hence the application to HiFi color). On the down side, FM screening requires greater precision from the equipment. The reproduction of microscopic laser spots demands very high resolution plates and precise production techniques. Manual film retouching (dot etching) is virtually impossible.

Because there is no screen ruling, scanning resolution formulae no longer apply, but there is some evidence that substantially lower scan resolutions may be used with FM screening. Frequency modulated screening will probably not eliminate halftones altogether, but it is gaining acceptance in the conservative prepress industry. It will certainly continue to be used for extremely high quality color printing using more than four ink colors, and it definitely has a place in digital presses such as the Heidelberg GTO-DI using the Presstek Pearl laser plate-imaging technology (see Appendix A). ▲

Chapter 5 Review Questions

1. What is the purpose of scanning?

2. Digital image manipulation software can more than make up for poorly scanned images (circle correct answer). True or False?

3. The ability of a scanner to distinguish detail in both dark and light areas of an image is referred to as _____.

4. A scanned image is a _____ image.

5. What is one of the most important factors in scanning?

Electronic Prepress: A Hands-On Introduction

126 ...

6. As long as the number of pixels per inch remains the same, the resolution of a digitized image can be changed without changing the file size (circle correct answer). True or False?

7. If the image area of a digitized image is enlarged and the number of pixels per inch remains the same, the resolution (circle correct answer):

a. decreases.

b. increases.

c. remains the same.

8. Multiplying output screen frequency by 2 is a simple formula for (circle correct answer):

a. determining the resolution of an output device.

b. determining the scanning resolution for an image.

c. determining number of gray levels in a pixel.

9. To preserve quality, more pixels must be added to a digitized image if it is enlarged (circle correct answer). True or False?

10. What system places scanned images on a compact disk.

Chapter 5 • Scanning and Image Manipulation

127

11. A popular software application for image manipulation is

_____.

12. What is image enhancement?

13. The tonal distribution of an image is displayed in a special graph

called a _____.

14. Halftone screens are used only for photographs (circle correct

answer). True or False?

15. Halftones create the illusion of _____

_____ of gray or color.

16. The term "line screen" is used to refer to (circle correct answer):

 a. the lines on a computer screen.

 b. a special halftone effect.

 c. the screen frequency of a halftone.

17. A higher screen frequency means there are more halftone dots per inch (circle correct answer). True or False?

18. Two factors other than screen frequency which affect halftones are

_____ and _____.

19. Digital halftone cells are always square (circle correct answer). True or False?

20. Pixel depth is the amount of information contained in each pixel (circle correct answer). True or False?

21. High quality digital color images require _____ per pixel.

22. High-resolution imagesetters make better halftones because (circle correct answer):

 a. they can fit more levels of gray into each halftone cell.

 b. they can output to film.

 c. they can create stochastic screens.

23. Frequency modulated screening is an attempt to emulate traditional halftone dots (circle correct answer). True or False?

Key Terms from Chapter 5

AM (amplitude modulated)
charge-coupled device (CCD)
color correction
digital halftone
digitizing
dot shape
dots per inch (dpi)
dynamic range
for position only (FPO)
frequency modulated (FM) screening
grayscale
halftone
halftone screen
histogram
image area
image editing software
image enhancement
image file size
image resolution

Kodak Photo CD System
laser spot (machine spot)
line screen frequency (lpi)
lines per inch (lpi)
moiré
pixel depth
pixels per inch (ppi)
Print Photo CD
random screening
scanned image (digitized image)
screen angle
screen frequency
sharpening
special effects
stochastic screening
supercell technology
TIFF/IT (Tag Image File Format for
 Image Technology)
tone correction

6

When you complete this chapter, you will have learned:

✔ how to identify problem areas in electronic page design.

✔ more about the basic computer graphics formats and their characteristics.

✔ more about key elements in the electronic prepress process.

✔ to identify the various proofing methods and how to evaluate a proof.

Page Layout and Proofing

Designing the Electronic Page

Until the advent of desktop publishing, graphic designers were mostly artistic types who were not called upon to be experts in such things as trapping and halftone imaging. After designing a publication, assembling photos and other illustrations, specifying type, and creating mechanicals, they could turn the job over to a commercial printing firm and be blissfully unaware of (and uninvolved in) the efforts needed to get the publication printed, folded, and/or bound. Of course, they would probably see and approve final film assembly through a proof, and in some cases, even go to the printing plant to approve the printed sheets as they came off the press. Even if they were unaware of, or indifferent to, the technical aspects of the prepress process, designers and production artists have always needed to be well-trained and experienced enough to provide a workable publication mechanical, or paste-up, as well as intelligible instructions as to what was desired.

Today, the transition from page design and layout to prepress and final printing is not so clearly defined, and the once-smooth exchange of materials between designer and technician can be a bit turbulent at times. In some instances there is simply a lack of communication. In others, the

originators of desktop publications are ill-informed and poorly educated to the intricacies of electronic prepress.

This chapter covers basic *electronic page layout* considerations and rules of thumb that help expedite the prepress and printing processes. The most important rule can be stated at the outset: always communicate as much as possible with your service bureau or trade shop. Other important guidelines are as follows:

- Don't be afraid to ask questions. A good trade shop will be more than willing to help you get the best possible results.

- Always number and clearly identify diskettes and SyQuest cartridges that you send to a trade shop.

- Provide a directory of files showing their disk locations, and make sure you're sending the latest revisions of your work. It's often a good idea to include dates and/or times of day in the file name to help keep track of revisions.

- Always make at least one backup copy of each file. The making of backups is an important work habit that is often neglected. Computer files can become mysteriously corrupt; computer disks can suddenly go bad. If you don't make backups, sooner or later you will deeply regret it.

Standards for the electronic prepress industry are now well established. One set of standards, the *Electronic Mechanical Specifications (EMS)* has been published by the Graphic Communications Association (GCA), an affiliate of Printing Industries of America Inc. The Scitex Graphic Arts Users Association (SGAUA) has developed another set of standards called *Computer Ready Electronic Files (CREF)*. Trade shops can often provide their regular customers with copies of these or other sets of standards. Addresses for these organizations are listed in Appendix B.

Working With Graphics

The two basic graphic image file formats, *bitmap* and *vector*, were discussed in Chapter 1 under the section "Illustration Software," but a brief review may be helpful. Terminology can be confusing, for the word *raster* is sometimes used instead of bitmap, and *object-oriented* is another term for vector.

The most important thing to remember, however, is the essential difference between the two types of files. Bitmapped graphics are digitized images in which image resolution is directly related to the number of pixel per inch; the more pixels per inch, the higher the resolution. The resolution of a bitmapped image is independent of any device. It is an integral part of the image itself. Conversely, a vector-image graphic is device-dependent for its resolution. This is because vectored images are created in a computer as paths and fills which have mathematical coordinates that define the image.

Bitmapped images are created by scanners or paint software applications and have a characteristic continuous-tone appearance where colors or shades blend more or less smoothly into each other—typical of photographs, and watercolor or oil paintings. Vectored images are created by drawing software applications or by the drawing tools in page layout software applications. Vector-image graphics usually appear hard-edged, using clearly defined shapes and lines filled with colors or patterns. The only continuous-tone appearance in a vector-image graphic derives from the use of blends or gradients of color or gray.

Typical file formats for bitmapped graphics are *TIFF (Tag Image File Format), RIFF (Raster Image File Format), BMP (Windows Bitmap),* and *MacPaint. PICT (Macintosh Picture)* and *EPS (Encapsulated PostScript)* are major formats for vector-image graphics on the Mac. On the PC/Windows platform, *WMF (Windows Metafile)* and *CGM (Computer Graphics Metafile)* are available as vector-image formats in most drawing applications. Both PICT and EPS can contain bitmap information. In fact, scanned images (bitmaps) can be saved in the EPS format, but TIFF is widely used. The *DCS (Desktop Color Separation)* file format was one of the first to address the issue of desktop color separations. The DCS format

creates five pre-separated EPS files that represent the original image and four separate files for each of the process colors (CMYK).

A key thing to remember about EPS files is that they will not display an image in a page layout software application unless an *image header* is present in the file. The image header is a bitmap image of the graphic (usually PICT or TIFF) that can be embedded in the EPS file when it's saved. The header is necessary to create a screen image because pure EPS files are composed only of PostScript code which can be read by an output device but not displayed on a monitor. Avoid embedding (nesting) one EPS file in another, as this can cause output problems. If it seems unavoidable, check with your trade shop for a possible solution.

Lines and boxes created in the page layout software application constitute the simplest graphics, and they can play an important role in visually organizing and enhancing the page design. Don't use the predefined "hairline" line width found in page layout software. On a high-resolution imagesetter or film recorder, it will produce a line so fine as to be nearly invisible. If you need a hairline, set the line width at .25 points.

Using a Proof

One of the most important terms in the electronic prepress industry is the word *proof*. A proof is any sheet of paper or film which is intended to show how the finished job should look. Final proofs may be in full color and show the desired results in jewel-like detail. Proofs are also used to communicate changes in the final layout and instructions to the prepress operators.

When sending an electronic publication to a trade shop, always include a hard copy proof from a laser printer or other desktop printer. Make sure the proof is from the final version and contains all the elements of the page layout. If possible, use a sheet large enough to show *crop marks,* especially if *bleeds* are present. A bleed is any element that runs off the edge of the page. In electronic page layout, bleeds are easy to create, but it must be remembered that bleeds may dictate a larger paper size, and consequently, greater expense.

Always identify color areas on the proof by indicating the type of ink color to be used. For example, mark Pantone colors with the PMS number and mark process screen tints with the percentages of each process color used to make the tint—70 percent cyan, 50 percent magenta, 20 percent yellow and so on.

FPO and Live Images

If you are working with a trade shop using the *OPI (Open Prepress Interface)* or *APR (Automatic Picture Replacement)* system, be sure to indicate which images on the proof are to be replaced at the trade shop. This is done by marking the image "FPO" (for position only) on the proof. *FPO images* may be low-resolution scans provided by the trade shop, or may be a sketch or photocopy placed directly on the proof.

When working with scanned images and other bitmaps, it is best not to scale (resize), rotate, flip, or otherwise drastically change the image after it has been placed in the page layout. To avoid output difficulties, these actions should be performed in an image manipulation software application or by the trade shop. If you are working with FPO images, always check with the trade shop before resizing, rotating, etc.

If you are using images created in desktop graphics applications such as Adobe Illustrator or Fractal Design Painter, or obtained from a scanner, digital camera, Photo CD, or video frame capture, mark them as *"live"* on the proof. This tells the service bureau or trade shop that a source file is linked to the image in the page layout software application. The original graphics files must be included on a disk with the page layout files when the job is sent to the trade shop. Be sure not to change the file names of graphics files after they have been placed in the page layout.

Working with Color, Traps, and Gradients

One of the most common errors in desktop page layout files concerns color separations. The most widely used page layout software applications—PageMaker and QuarkXPress—have the ability to output *process color separations* for any color used in the page layout, no matter what color model was used to make the color. In other words, a Pantone color can be output as process color separations if desired. This practice is usually not recommended, but it can happen through oversight.

The key to preventing such an error is first to understand the difference between *spot color* and *process color* printing (see Chapter 4, "The Basics of Color Reproduction"), and then to make sure the process color separation command is not used for Pantone and other spot colors.

Other problems can arise with color due to the difference in the way colors are displayed on the monitor and how they look when printed. Although color calibration systems exist (notably the *EFI Color Extension* in QuarkXPress), color viewed on a computer monitor can never look exactly like color printed on a surface. Protect yourself by always working from a *color swatch book* such the the Pantone Color Formula Guide.

If you work with a desktop color printer, it's a good idea to print out sample sheets of all the colors you use so that you can see exactly how the colors really look when printed. Bear in mind, however, that the colors may shift again when actually printed on a printing press. Be aware of the changing nature of color perception. It is, and always has been, one of the biggest challenges in the graphics industry.

We have discussed *trapping* elsewhere in this book (Chapter 4, "Color Trapping"), so suffice it to say that you must communicate with your trade shop about this issue. It may be best for them to have all trapping responsibilities. If you will be doing the trapping, find out from the printing shop how much trap to use, and *be sure you know what you're doing.*

Color gradient features are now common in both page layout and drawing software applications. Sometimes these gradients can cause problems with some output devices or RIPs, so you should check with your trade shop before using them. Above all, make sure any special color or

graphics effect you create on your computer can actually be turned into output. Remember, if it won't print on your laser printer, it may not print at the service bureau.

The Right Type

The typographic elements of an electronic page layout seldom cause technical problems anymore. The biggest problem with desktop typography is an aesthetic one. The art of typography is not as simple as it appears, and type is often badly misused in desktop publishing. There is not room in this book for a course in typography, so it must deal only with the most obvious problems than can arise in electronic prepress.

First, make sure you are using the same font technology used by the trade shop you are working with. *Adobe Type 1 fonts* seem to have become the industry standard, but *Apple's TrueType fonts* are also common. The trade shop or service bureau must have the same specific fonts that you have used in your electronic publication. In Adobe Type 1, each font is composed of two files: the *screen font* and the *printer font*. The printer font file must be present in the trade shop's system to output your publication, and it's illegal for you to simply give it to them. It's OK to provide the screen fonts, however. Always provide the trade shop with a list of the fonts you have used, including any that you used in EPS graphics.

Type Styles and Type Effects

Because a typeface includes a whole family of variations on one basic type design, *type styles* are an integral part of the typeface. The most common names for these styles are "thin," "light," "medium," "bold," "black," "italic," "light italic," "medium italic," and "bold italic." Not all typeface families contain all these styles, but when they do, it's desirable to have them installed on your computer.

It's best not to use the computer-generated styles found in the "Style" menus of word-processing and page layout software applications, especially the "outline" and "shadow" styles. Create outline and shadow

effects in a drawing application and import them into the page layout for best results. When using *"reverse" type,* be certain the background of the reverse is dark enough for the letters to be readable.

Proofing Methods

The laser proof you send to the trade shop is only one of the ways that a proof is used. The same type of output from a desktop printer is also a good way to communicate design concepts and textual content to a colleague, client or supervisor. It must always be remembered, however, that desktop color printers may not render color accurately. Still, a desktop color printer proof is useful as a first-level visual aid to communication with clients and others.

The most important kind of proof is the one that indicates as closely as possible how the publication will look when it's printed on a printing press. In fact, such a "final" proof is usually intended as a standard to be matched by the printing technicians, and it acts as a basis of approval (and in some cases, a contract) for the final print run. Proofs can be categorized into three types: *digital proofs, off-press proofs,* and *press proofs.* Proofing methods should be evaluated on the basis of accuracy, cost, and time.

Digital Proofs

The cheapest, quickest, and least accurate digital proof is the computer monitor. This is sometimes referred to as a *"soft proof."* New technologies may improve color display, but for now, one should never rely upon a monitor for accurate color.

Desktop printers supply digital proofs in the form of thermal wax, laser print, dye sublimation, and ink-jet output. Desktop printer proofs should be used primarily as color comps, as they are quick and inexpensive, but lack color accuracy. *High-end digital proofing,* or *direct digital color proofing (DDCP),* is becoming widespread with products such as the *Digital MatchPrint* by 3M, *4Cast* by DuPont, and *Pressmatch,* a dye sublimation system developed jointly by Hoechst (PPNA) and SuperMac Technologies.

High-quality digital proofs have good color fidelity and are generally less expensive and faster to make than traditional proofs. They may even have superiority in showing *dot gain* variability among colors and emulating *ink trap* on the press. Dot gain describes the tendency of halftone dots or cells to enlarge slightly when printed with ink on paper, resulting in an increase in ink coverage and more intense colors. Ink trap refers to the accumulation of different ink colors in areas of high coverage.

There is some objection to DDCP in the prepress and printing industry because digital proofs are not made from the actual color separation film. For this reason, many commercial printers are unwilling to use them as contract proofs, feeling that they are not accurate enough.

Off-Press Proofs

Traditional, or *analog*, proofs are made directly from the film negatives that will be used to make printing plates. They are of three types: *blueline, overlay* and *laminated*. Blueline proofs are *monochrome* and do not show separate ink colors. Their main purpose is to show that the pages have been assembled correctly. DuPont *Dylux* is the most common brand of blueline proof.

Overlay proofs, such as 3M *Color Key* and DuPont *Chromacheck*, are made up of four pieces of clear acetate film mounted on a white backing. Each of the four pieces of film shows one of the process color screens that make up the image. Putting them all together shows the whole image, but colors tend to be inaccurate due to the density of the acetate film. Each sheet of acetate can be lifted and examined separately, however.

Laminate proofs (a.k.a. integral) are much more accurate than overlays, and they cost more. In a laminate proof such as 3M *MatchPrint* or DuPont *Cromalin*, each of the process colors is on thin photographic film laminated to white paper. The films are melded together and cannot be examined separately. Both overlay and laminate proofs take a bit longer to obtain than digital proofs.

Press Proofs

As the name suggests, press proofs are made on a printing press using the plates, ink, and paper that are to be used for the actual print run. For obvious reasons, this type of proof is the most accurate and the most expensive and time consuming. A form of press proof called a *progressive* is often made for a premium printing job. Progressives are composed of a separate sheet showing each color, sheets showing various combinations of colors, and finally, a sheet showing all four (or more) colors together.

Another form of proofing is the *press check*. In a press check, someone goes to the printing plant and examines the first sheets off the press, usually comparing them to a previous proof. Making changes at this stage can be prohibitively expensive, but some adjustments in color can routinely be made on the press.

Evaluating a Proof

The evaluation of a proof is a subjective activity, and can be influenced by personal bias, mood, and background experience. Still, there are some rules of thumb which can help one be more objective. The first rule in evaluating any proof other than a press proof is that it may represent colors in a way that cannot actually be accomplished on the press.

Very high quality color is difficult and expensive to achieve, and today we are seeing greater acceptance in the marketplace for "good-enough" color produced on the desktop. The rationale for good-enough color derives from reduced cost and turnaround time, but it has created a schism between prepress professionals and desktop publishers. Generally, the conservative prepress and commercial printing industry would rather uphold a higher standard for color, and the emergence of desktop color has been cause for alarm, resentment, and some paranoia on their part.

The following guidelines are helpful in evaluating the more accurate types of proofs:

- When evaluating a color proof, make sure the images reasonably match the original and that flesh tones and food look natural.

- Images should be bright and sharp with detail in the highlights.

- There should be no moiré patterns or streaking and banding.

- There should be no odd overall color cast, such as faint tints of green or blue in the neutral areas of the image.

- If the proof shows entire page layouts, check that all page elements are in the correct position and that there is no broken or unreadable type.

- Check for spots and scratches that may represent dust, pinholes, or scratches on the film.

A careful examination of the proof cannot be over-emphasized, for the consequences of unnoticed errors can be financially devastating. ▲

Chapter 6 Review Questions

1. The most important factor in dealing with a trade shop or service bureau is (circle correct answer):

 a. money.

 b. communication.

 c. location.

2. An important, but often neglected, work habit is (circle correct answer):

 a. backing-up computer files.

 b. sitting up straight.

 c. arriving on time.

3. What are the acronyms for two well-known sets of electronic pre-press industry standards?

4. The two basic types of electronic graphic images are

 _____ and

 _____.

5. TIFF is a frequently used format for vector images (circle correct

answer). True or False?

6. EPS files require an _____

if they are to be displayed in a page layout software application.

7. What is the definition of a proof?

8. It's not necessary to send a desktop printer proof to the trade shop

(circle correct answer). True or False?

9. FPO means

_____.

10. A "live" image is one that (circle correct answer):

a. will be replaced at the trade shop.

b. is linked to a source file.

c. has not been discarded.

11. One cannot output Pantone colors as process color separations (circle correct answer). True or False?

12. The biggest problem with desktop typography is an

_____ one.

13. It's OK to give away printer font files (circle correct answer). True or False?

14. Name one type style.

15. What are the three categories of proofs?

16. The "soft proof" is the best all-around type of proof (circle correct answer). True or False?

17. What is the main objection to digital proofs?

18. Two well-known brand names of laminated proof are

_____ and _____.

19. A progressive is an elaborate form of _____.

20. One can always expect the colors in a print job to exactly match the

proof (circle correct answer). True or False?

Key Terms from Chapter 6

4Cast
Adobe Type 1 fonts
analog
Apple TrueType fonts
APR (Automatic Picture Replacement)
bitmap
bleeds
blueline proof
BMP (Windows Bitmap)
CGM (Computer Graphics Metafile)
Chromacheck
Color Key
color gradient
color swatch book
Computer Ready Electronic Files (CREF)
Cromalin
crop marks
DCS (Desktop Color Separation)
Digital MatchPrint
digital proof
direct digital color proofing (DDCP)
dot gain
Dylux
EFI Color Extension
Electronic Mechanical Specifications (EMS)
electronic page layout
EPS (Encapsulated PostScript)
FPO image
high-end digital proofing
image header

ink trap
laminated proof
live image
MacPaint
MatchPrint
monochrome
object-oriented
off-press proof
OPI (Open Prepress Interface)
overlay proof
PICT (Macintosh Picture)
press check
press proof
Pressmatch
printer font
process color
process color separations
progressive proof
proof
raster
reverse type
RIFF (Raster Image File Format)
screen font
soft proof
spot color
TIFF (Tag Image File Format)
trapping
type style
vector
WMF (Windows Metafile)

Appendix A

Graphics Reproduction Methods

Offset Printing

Offset printing, or offset lithography, is the most widely used commercial printing method. It produces high-quality results quickly and inexpensively compared to other methods. Lithography literally means "writing with stone" (from the Greek *lithos,* a stone, and *graphia,* writing), and printing with smooth limestone blocks is still done in the fine arts.

The process is based on the principle that oil (in this case, ink) and water do not mix. In both traditional lithography and offset lithography, water in the non-image areas of the plate keeps ink only in the image area. Paper is pressed directly on the stone surface in traditional lithography, but in offset lithography the ink is transferred from a metal or plastic plate to a rubber blanket. The blanket then transfers the image to the paper, hence the term offset.

Offset printing presses have different mechanical components; each with a specific job to do. Paper is loaded through a feeding unit and precisely positioned by the register unit. Ink and water units feed the printing units which transfer images to the paper. Finally, delivery units stack and provide access to the printed sheets.

Each unit must be carefully adjusted and kept that way by the press operator to obtain consistent results throughout the print run. Whether the press is a small manually-adjusted one or a large automated one, press operators must work hard to produce excellent results. It can be a thank-

less task, for many customers are extremely demanding (many press operators would use a stronger term).

Offset presses are categorized as either sheetfed or web. The only real difference in the two is in the paper delivery system. Paper is fed into a sheetfed press as sheets of varying sizes, but a web press is fed from a large roll of paper. Presses can be further distinguished as to the largest size paper they can handle. Small sheetfed presses, such as the Multilith or A.B. Dick, are also called duplicators and can print on sheets up to twelve by eighteen inches. They are often used to print only one color of ink, but some are capable of more.

Large sheetfed presses come in a variety of sizes, and this category covers anything that can print from twelve by eighteen inches up to fifty-five by seventy-eight inches. Many commercial printers consider a twenty-five by thirty-eight-inch press size to be ideal. Common brand names for offset presses are Harris, Heidelberg, Komori, Miehle, Maruka, and Royal Zenith.

Web presses are generally considered more economical than sheetfed for large print jobs, but the point at which this happens depends on individual circumstances. Any print job with a quantity over 20,000 press sheets might be more economical to run on a web press. A quantity of 100,000 or more press sheets definitely calls for a web press. Of course, a press sheet may carry more than one copy of the whole publication. The size of the press sheet is part of the cost equation that must be worked out by an estimator.

Like large sheetfed presses, web presses come in different sizes and are distinguished by the size of paper they can handle. The forms web is the smallest and is used to print business forms and other pieces from a seventeen-inch wide roll of paper. Half webs use paper rolls up to twenty-six inches wide, and full size commercial webs can print sixteen-page signatures from thirty-eight-inch rolls. Speed is the main advantage of web presses.

Many presses can print more than one color in one pass. A multicolor press may have up to eight sets of ink cylinders—each capable of applying a separate color or varnish as the press sheet runs through. A perfecting multicolor press can print both sides of the sheet in one pass.

A newer offset printing technology eliminates the need for water to resist ink on the printing plate. In waterless printing, a silicone coating on the plate does the job of water. Proponents of this system claim that it practically eliminates dot gain, allowing for the use of very fine screen frequencies (up to 660 lpi). The system seems to have other advantages, such as better and more consistent ink coverage, faster make-ready, and less environmental impact.

Letterpress

Letterpress printing can be compared to using a rubber stamp—letters or images are printed from a raised, inked surface (the plate). In western culture, a fifteenth century German artisan named Johann Gutenberg is credited with the invention of movable type which could be inked and pressed onto paper, but there is considerable evidence that the process dates back to ancient China.

The three basic types of letterpress presses are: platen, flatbed cylinder, and rotary. A platen press opens and closes like a clamshell and prints one sheet at a time. This type of press is used for short-run jobs such as invitations, announcements, personal stationery, and so on. Embossing, die-cutting, and scoring is done on large platen presses. The market for letterpress has declined to the point that flatbed cylinder and rotary presses are almost obsolete. A flatbed cylinder press works by rotating a cylinder holding the paper over a moving flatbed which holds the inked form. In a rotary press, two cylinders roll together with paper between them. One cylinder holds the printing plate and the other provides pressure.

Screen Printing

Screen printing is the simplest of all graphics reproduction methods, requiring only a screen made of silk or some other fabric, ink, and a squeegee. In a manual operation, the screen is mounted on a frame and placed on the surface to be printed. Ink is forced through the screen with the squeegee, which is a thick rubber blade with a wooden or plastic handle. The printed image results from ink being forced through a

stenciled image on the screen. Stencils can be either hand- or machine-made, or an image can be exposed photographically on a screen with a light-sensitive emulsion.

Commercial screen printing operations range from cottage industries using the labor-intensive manual technique to large companies with multiple automatic presses. Although bigger and faster, automatic silk screen presses use the same basic technique. Screen printing is ideal for small quantities of signs, posters, bumper stickers, T-shirts, and so on. It lends itself well to printing extremely large images such as billboards. In fact, almost any surface or three-dimensional object can be screen printed.

Flexography and Gravure

Flexography was developed as a way to print on nonporous substances such as plastic or foil. It is usually done on a web press using rubber or photopolymer plates and fast-drying, fluid inks that can adhere to the nonporous surfaces. Flexography is used to print grocery bags, bread wrappers, and other packaging materials, but it is also used to print on corrugated cardboard, wallpaper, and other rough material when larger quantities make screen printing not cost-effective.

If you use an 8x or 10x magnifier to examine a large bold letter on any text page of a recent issue of *National Geographic* and then compare it to a similar letter in an advertisement running in the same issue, you will see the difference between gravure and offset lithography. Editorial pages in *National Geographic* are printed with the gravure process, but advertising pages are printed with lithography. Because gravure (also called rotogravure) printing uses cylindrical plates where images are composed of microscopic ink-filled cells, even solid black type appears to have been printed as a halftone. The effect is most apparent on the edges of a solid image, where the tiny cells can just barely be seen.

Gravure plates are mounted on web presses where they transfer ink directly to the paper. Gravure works well on low-grade paper and is often used for direct mail advertising pieces. Gravure is almost always used for extremely large printings because the plates are expensive, but also because ink coverage is so consistently good from beginning to end.

Photocopying

Photocopying machines compete with small offset printing presses in both speed and quality. Using a powdered toner, a photocopier makes copies from an original by duplicating a photographic image on an electrostatically charged drum. The toner adheres to the charged image area and is transferred to paper or film where it is fused with heat. Duplicating by photocopy is most economical for relatively small quantities (under 300). Computer controlled photocopiers are a common form of desktop publishing technology where documents can be created and instantly printed.

Digital Presses

Whether or not they are ushering in a new era in the color publishing industry remains to be seen, but digital presses are definitely gaining popularity. Their main advantage seems to be an ability to economically provide short-run color printing. What constitutes a "short-run" is open to interpretation, but digital presses make it feasible to print only a single copy. Whether the quantity is one or 10,000, digital presses have other advantages that make them attractive: fast turnaround, reasonable cost, and high quality. They are also earth-friendly, as they waste less paper and use fewer toxic chemicals. Digital presses print directly from electronic publication files, and all the prepress operations associated with platemaking are eliminated.

Some digital presses are similar to laser printers, although much more sophisticated. They utilize Mac or PC workstations and a raster image processor (RIP). Two of the earliest entries in this field are Xeikon and Indigo. The Xeikon DCP-1 can simultaneously print full bleed color on both sides of an eleven by seventeen-inch sheet using dry toners and eight imaging cylinders. It transfers 600 dpi images directly to paper from an electrostatic drum and uses heat fusing. Paper is web-fed into the printer from a 12.6-inch roll. AM Multigraphics is the North American distributor for Xeikon, which is based in Belgium. Agfa has developed a digital press (the Chromapress) using the Xeikon engine.

The Indigo E-Print series uses a liquid toner, and images are transferred from an electrostatic drum to an offset blanket cylinder which transfers the image to paper. The toner is a special polymeric ink called ElectroInk which hardens on the paper quickly without heat fusing. The E-Print is sheet-fed, provides a 800 dpi resolution, and prints up to eleven by seventeen inches. The E-Print 1000 has only one imaging cylinder, requiring four passes to print four colors. The E-Print 4000 has four imaging stations and can print four colors simultaneously on one side of the sheet. The E-Print has an integrated Sun SPARCstation and links to both Mac and PC workstations generating PostScript files.

The Heidelberg GTO-DI with Presstek's Pearl plate imaging technology is a modified offset lithography press. Pearl is a laser imaging technology which uses laser diodes to image plates directly on the press cylinders. The printing process is waterless because the plates use silicon to repel ink. The GTO is a bonafide offset press, however, and the direct imaging of plates is what makes it "digital." As an offset press, it's capable of much higher resolutions and greater speed than the xerographic digital presses. ▲

Appendix B

Associations and Magazines

Associations

Association of Desktop Publishers
1718 Connecticut Avenue NW, Suite 700
Washington, D.C. 20009
(202) 232-3335

Association of Imaging Service Bureaus
5601 Roanne Way, Suite 605
Greensboro, North Carolina 27409
(919) 632-0200

Graphic Communications Association
100 Daingerfield Road
Alexandria, Virginia 22314-2804
(703) 519-8160 FAX (703) 548-2867

International Prepress Association
7200 France Avenue South, Suite 327
Edina, Minnesota 55435
(612) 896-1908

Scitex Graphic Arts Users Association
305 Plus Park Boulevard (37217)
P.O. Box 290249
Nashville, Tennessee 37229

Magazines

Byte
Editorial
One Phoenix Mill Lane
Peterborough, New Hampshire 03458
(603) 924-9281
Subscriptions
P.O. Box 555
Hightstown, New Jersey 08520
(800) 257-9402

Color Publishing
Editorial
Ten Tara Boulevard, 5th Floor
Nashua, New Hampshire 03062-2801
(603) 891-9116 FAX (603) 891-0539
Subscriptions
P.O. Box 2709
Tulsa, Oklahoma 74101

Graphic Arts Monthly
249 West 17 Street
New York, New York 10022

HOW
The Bottomline Design Magazine
P.O. Box 5250
Harlan, IA 51593-0750
(800) 333-1115
MacUser
Editorial
950 Tower Lane, 18th Floor
Foster City, California 94404
(415) 378-5600

Subcriptions
P.O. Box 56986
Boulder, Colorado 80322-6986
(800) 627-2247

MACWORLD
Editorial
501 Second Street, 5th Floor
San Francisco, California 94107
(415) 243-0505
Subscriptions
P.O. Box 54529
Boulder, Colorado 80322-4529
(800) 234-1038

PC Magazine
Editorial
One Park Avenue
New York, New York 10016-5802
(212) 503-5255
Subscriptions
P.O. Box 54093
Boulder, Colorado 80322-4093
(800) 289-0429

Publish
Editorial
501 Second Street
San Francisco, California 94107
(415)978-3280
Subscriptions
P.O. Box 5039
Brentwood, Tennessee 37024
(800) 685-3435

Glossary

Additive System—defines the RGB computer color model in which red, green, and blue combine to make white.

Adobe Type 1 Fonts—the PostScript computer font technology developed by Adobe Systems, Inc., which has become standard in the electronic prepress industry.

Analog—refers to a system that represents or manipulates data by measuring voltage, providing information in non-discrete values rather than in discrete signals (digital). An electro-mechanical clock with gears represents an analog system.

Apple TrueType Fonts—the computer font technology developed by Apple Computers, Inc., which is characterized by a single-file display and output scheme.

ASCII Code—(American Standard Code for Information Interchange), a system of binary signals representing computer characters as bytes.

Automatic Picture Replacement (APR)—a system developed by Scitex America for automatically substituting high-resolution digital images in place of low-resolution placeholder images.

Binary—a system of processing data in which only two states exist, such as, on or off, zero or one, high or low.

Bit—the fundamental unit of digital information processing, representing pulses of electricity interpreted as either zeros or ones (as in binary code).

Bit Depth—the measurement of how many bits of information a pixel is able to store. Often applied to computer monitors as in 8-bit or 24-bit display.

Bitmap Image—a digital image which has a fixed number of pixels per inch (ppi) unaffected by the resolution of an output device such as a laser printer or imagesetter. When printed, bitmap images are converted to digital halftones, and the line screen frequency (lpi) options are directly related to the original bitmap resolution (ppi).

Blanket—refers in graphic arts to the rubber blanket on an offset press that transfers ink from plate to paper.

Bleed—a term applied to any element or image on a printed page that runs off the edge of the page. In page layout, such elements must be extended beyond the edge of the page about one-eighth of an inch so that the extra can be trimmed off after printing.

Blueline Proof—a type of monochrome (single color) page proof created on photosensitive paper. When exposed, the paper yields a blue tone.

Bus Network—a type of local area network (LAN) in which computers and other digital devices are attached to a length of cable.

Byte—a measurement of digital data equal to eight bits in a microcomputer.

Cache Memory—high-speed computer memory which allows the temporary storage of recently used data and operating instructions. Cache memory is similar to RAM, but faster.

Camera-Ready Art—a term applied to any finished graphics material, such as a page layout or logo design, that is ready to be photographed by a reprographics camera preliminary to making printing plates. A traditional mechanical is camera-ready art.

CD ROM (Compact Disk Read-Only Memory) Drive—a computer peripheral which reads and transmits data to the computer from a compact disk. The device does not allow data to be recorded on the compact disk.

Charge-Coupled Device (CCD)—a computer chip used in scanners to convert photons (light energy) into electrons (electrical energy).

Choke—to reduce the size of a knock out in the process of color trapping.

CIELAB/CIEXYZ—international color standards developed by the *Commission Internationale de l'Eclairage.*

CISC (Complex Instruction Set Computing)—a microprocessing chip architecture in which the chip contains a large set of operating instructions (instruction libraries). CISC-based computers are slowed down by the large instruction libraries which contain many common complex instructions.

CMYK (Cyan, Magenta, Yellow, Black)—the ink colors used in process color printing.

Coated and Uncoated Paper Stock—refers to the two basic paper surfaces used in most commercial printing. Coated paper has a hard glossy, semi-glossy, or matte surface (usually clay) created when the paper is manufactured. Uncoated paper lacks the special clay coating and has a matte surface.

Color Key—a type of color proof developed by 3M in which the four process colors (CMYK) are reproduced on separate overlay sheets of acetate film.

Color Electronic Prepress Systems (CEPS)—expensive high-end prepress systems which incorporate proprietary hardware and software and are usually installed at trade shops.

Color Gamut—the range of colors that a device or system can reproduce, also known as color space.

Color Gradient—a graduated range of colors in which color blends through various tints either of the same color or between two colors.

Color Halftone—a continuous-tone image which has been converted to dot screens to reproduce the color and tonal values of the original. The original image is color-separated to provide a separate screen for each of the four process colors (CMYK).

Color House (Color Trade Shop, Film House, Color Separator)—a commercial business that provides prepress services, such as scanning, color-separating, and page imposition, to commercial printing firms and other graphics industry businesses.

Color Model—a software feature providing a structure for the representation of color on a computer.

Color Separation Film—film negatives used to make printing plates for each of the four process colors (CMYK).

Color Separations—to generate separate pieces of film or other graphics reproduction material for each process color (CMYK) or spot color.

Color Swatch Book—a book of color samples representing ink colors as they will look when printed.

Color Trapping—the process of adjusting separate color elements so they will print with a slight overlap of the colors, preventing gaps between the elements due to normal misregistration on a printing press.

Colorimetry—the science of measuring and specifying colors.

Commission Internationale de l'Eclairage (CIE)—an international commission formed for the purpose of devising a universal color standard.

Comp (Comprehensive)—a representation of the design and layout of a publication devised for the purpose of communication prior to actual execution of final mechanicals for printing.

Computer Network—a group of computers and peripheral devices connected to each other by cables.

Computer Ready Electronic Files (CREF)—a set of standards for desktop publishing and electronic prepress developed and published by the Scitex Graphic Arts Users Association (SGAUA).

Continuous-Tone Art—an original graphic image that displays complex tonal values often blending smoothly together, such as in a photograph or painting.

CPU (Central Processing Unit)—the part of a computer system that processes instructions and information, comprised of a logic unit, a control unit, a clock, and memory.

Cromalin—a type of integral color proof developed by DuPont.

Crop Marks—printed lines that indicate page size or image area where excess paper will be trimmed away, usually located at each corner.

DCS (Desktop Color Separation)—a computer file format consisting of five files: a master file containing a PICT version of the image for screen display and four EPS color separation files, one for each of the process colors (CMYK).

Dedicated Workstation—a high-performance computer dedicated to a specific primary function, such as color separating and color adjustment.

Designer's Layout—refers to the practice of graphic designers to create mechanicals in one and two-page units with pages sequentially numbered and left and right pages facing each other—also known as reader's spreads.

Desktop—the Macintosh file-management display of windows and folders, created by the Finder file.

Desktop Publishing—the process of creating printed materials with personal computers.

Desktop Scanner—a device for digitizing images that is compact enough to fit on a desk or work table with a personal computer and printer.

Device-Dependent—a process or system that performs according to specifications provided by a separate device.

Device-Independent—a process or system that does not rely on any separate device for content, resolution, calibration, or accuracy.

Digital—a system of discrete symbols used to represent and manipulate data.

Digital Camera—a camera that records images to digital circuitry rather than film.

Digital Color—color represented and reproduced by digital devices such as scanners and computers.

Digital Color Press—a printing press designed to directly utilize digital data to reproduce color publications.

Digital Halftone—an image composed of regularly-spaced cells that emulate the dots of a photomechanical halftone. The cells of a digital halftone are composed of grouped-together laser spots created by an output device such as an imagesetter.

Digital Prepress—another term for electronic prepress.

Digitized Image—an image, such as a photograph, processed by a scanner into digital data.

Digitizing Tablet (Graphics Tablet)—an input device for computers that utilizes a pressure sensitive surface (tablet) and a pen-like stylus.

Direct Digital Color Proof (DDCP)—a proof made directly from digital data rather than from film.

Direct-to-Film Output—a process of imaging desktop publications directly from a computer onto film negatives or positives rather than paper.

Direct-to-Plate Output—a process of imaging desktop publications directly from a computer onto a printing plate, bypassing both paper and film.

Direct-to-Press System—any system for reproducing desktop publications on a printing press that does not include paper, film, or off-press plate-making processes.

Diskette—usually refers to a three and one-half inch computer diskette which is composed of a flexible disk of magnetically sensitive material permanently mounted in a rigid plastic sleeve.

DOS (Disk Operating System)—the computer operating system developed in 1981 by Microsoft Corporation that has become the standard for IBM-compatible personal computers (also known as MS-DOS).

DOS-Based Computer—a computer that uses DOS as an operating system, usually referring to the IBM PC or compatible (clone).

Dot Gain—the phenomenon of halftone dots printing larger on paper than they appear on film or plate.

Dot Screen—refers to the arrangement of halftone dots in rows where each dot is equidistant from the next, creating a regular screen measured in terms of the number of rows (lines) per inch.

Dot Shape—the shape of a dot (round, elliptical, etc.) in a halftone screen.

Dot-Matrix Printer—a low-resolution computer output device that prints text and graphics by impacting small pins against an inked ribbon, creating images composed of clearly discernible patterns of square dots.

Dots Per Inch (dpi)—a measurement of display and output resolution for computer monitors, scanners, laser printers, and imagesetter.

Drafting Machine—a device used for mechanical drawing (engineering, architectural, etc.) constructed of jointed metal arms with plastic straight-edges creating a right angle.

Drawing Software—software providing tools for precisely controlling lines, shapes, and fill patterns to create vector images.

Dye-Sublimation Printer—a digital color output device utilizing solid dyes that impregnate the paper surface after being converted to a gaseous form with heat.

Dylux—a type of blueline proof developed by DuPont.

Dynamic Range—the range of difference in tonal values from the darkest to the lightest areas of an image.

EfiColor Xtension—a color management system developed by Electronics for Imaging for QuarkXPress. EfiColor uses CIE color definitions to interpret and display digital color consistently on multiple devices.

Electronic Mechanical Specifications (EMS)—a set of standards for desktop publishing and electronic prepress developed and published by the Graphic Communications Association (GCA), an affiliate of Printing Industries of America Inc.

Electronic Mechanical—the page layout and design of a publication created on a computer and output on a digital device such as a laser printer or imagesetter.

Electronic Prepress (EPP)—digital processes dedicated to the preparation of materials to be printed on a printing press.

EPS (Encapsulated PostScript)—a computer file format for vector images utilizing the Adobe PostScript page description language.

FEP (Front-End Platform)—refers to computer systems originating publication or image files that will be processed by high-end prepress systems. The Macintosh is often used as a FEP.

File Server—a computer that provides other computers access through a network to its storage memory so that files and programs can be shared.

Film Negative—photographic film carrying images in which blacks in the original are clear and whites in the original are black (a negative image).

Film Recorder (Laser Plotter)—In electronic prepress, a fast, high-resolution output device capable of very high quality color separation and halftone output. A slide film recorder is a different type of device used to output 35 mm color slides.

Film Separations—refers to the film negatives (or positives) resulting from either digital or photomechanical color separation processes.

Flat—an assemblage of negatives used to make printing plates. The term is also used to describe a lack of contrast in a photograph or halftone.

Floppy Disk—usually refers to a five and one-quarter inch computer disk contained in a flexible sleeve and commonly used with IBM-compatible computers.

FM (Frequency Modulated)—a term used to describe a type of radio wave and used in the electronic prepress industry to describe the imaging technology that utilizes random laser spots generated by an imagesetter. See Stochastic Screening.

Focoltone—a color matching system, originally developed in Wales, sometimes used by graphic designers and commercial printing firms to select process colors.

FPO (For Position Only) Image—a low-resolution image placed into an electronic mechanical for the purpose of showing its position relative to text and other elements and not intended for reproduction. The FPO image is replaced by a high-resolution image during the electronic prepress process.

Ganging—to group similar images to be scanned all at the same size and resolution.

Gateway—see Software Link.

Gigabyte (GB)—a unit of computer memory measurement equal to 1024 megabytes.

Graphic Designer—a person who plans, initiates, and controls how printed material will look by working with type, graphic images, color, paper and other elements.

Gray Component Replacement (GCR)—a variation of undercolor removal (UCR) in which ink coverage is controlled in process color printing by using black ink to replace the gray component created whenever halftone dots of cyan, magenta, and yellow are present in the same color.

Grayscale—a digital image in which a continuous-tone original is converted by a scanner to pixels containing various levels of gray.

GUI (Graphical User Interface)—a computer interface in which processes are displayed and controlled as graphic objects (often with a mouse) in a two-dimensional environment. Icons, windows, and menus are typical of a GUI.

Halftone—refers to an image in which continuous tones of gray or color have been converted into dots or cells for the purpose of printing.

Halftone Screen—the linear arrangement of dots or cells that make up a halftoned image. See dot screen.

Halftone Screening Algorithm—a set of computer-generated instructions that enable a device such as a film recorder to create digital halftones.

Hard Disk (Hard Drive)—a rigid, magnetically-sensitive disk for storing computer data, contained either within the housing of the computer (internal) or in a separate housing (external).

Hardware Link—a device used to link standard desktop publishing components to high-end proprietary electronic prepress systems.

High Fidelity (HiFi) Color Printing—specialized printing processes dedicated to reproducing as closely as possible the original colors, dynamic range, and other subtle nuances of original continuous-tone art.

High-End Electronic Prepress—electronic prepress processes with an implied superior standard of quality, usually referring to proprietary CEPS.

High-End Scanner—a device capable of higher resolutions, greater speed, and better color than a desktop scanner.

High-Resolution Imagesetter—a digital output device utilizing laser technology to create high-resolution images on photographic film or resin-coated paper.

Histogram—a graph showing the distribution of pixels representing all the tonal values of an image from the lightest to the darkest.

HSB Model—a computer color model based on hue, saturation, and brightness.

HSL Model—similar to the HSB model but stated as hue, saturation, and lightness.

Hue—the color name, such as red, purple, etc.

Icon—a symbolic image representing software, files, functions, and so on in a graphical user interface.

Image Area—the area within the margin guides of the page in page layout software applications; the maximum possible area that can carry an image in laser printers, imagesetters, and film recorders.

Image Assembly—see Imposition.

Image Editing Software—software such as Adobe PhotoShop which allows digitized images to be manipulated at the pixel level.

Image File Size—the number of bytes (kilobytes, megabytes, etc.) composing an image stored on a disk.

Image Header—the bitmap screen image embedded in a vector graphics file, enabling it to be viewed on a computer monitor.

Image Manipulation Software—see Image Editing Software.

Image Resolution—the number of pixels per inch (ppi) in a digitized image or the number of dots per inch (dpi) an image has when it is output.

Imagesetter—see High-Resolution Imagesetter.

Imposition—the arrangement of publication pages during the stripping process to determine how they will be printed on a printing press. See Signature.

Imposition Form—the entire set of publication pages after they have been stripped together into flats. See Flat and Stripping.

Ink Coverage—the area of a printed page actually covered by ink.

Ink Trapping—a condition in process color printing resulting when heavy concentrations of cyan, magenta, and yellow inks are present in an area of the image.

Ink-Jet Printer—a type of output device utilizing liquid ink sprayed onto the paper by tubes.

Input Device—a device such as a keyboard or mouse used to enter data or commands in a computer.

Internet—a wide area network (WAN), originally developed by the U.S. government and used extensively by government, university, and industrial research institutions, now gaining popularity among computer users all over the world as the "information superhighway."

Kerning—the typographic process of deleting or adding small amounts of space between pairs of characters.

Kilobyte (K)—a measurement of digital data equal to 1,024 bytes.

Knock Out—to remove an area of a background color in the same shape as a foreground element so that its color will not overprint the background color.

Kodak Photo CD System—a system for digitizing color photographs and storing them on a compact disk developed by Eastman Kodak.

Laminated Proof—a type of proof, such as the DuPont Cromalin, in which overlays of thin film bearing the process colors are laminated to a sheet of white paper to form a halftone image.

Laser Printer—a type of output device utilizing laser technology to fuse toner onto paper.

Laser Spot—the smallest mark that an imagesetter or film recorder can make when creating an image on paper or film; also called a machine spot.

Line Copy—a black and white image, usually refers to typographic elements and non-continuous tone graphics.

Line Screen Frequency—a measurement in lines per inch (lpi) of the number of dots or cells in a halftone screen, such as 65 lpi, 133 lpi, etc.

Lines Per Inch (LPI)—the number of dots or cells in a linear inch of a halftone screen.

Linotronic—a brand of imagesetter developed by the Linotype Company (now Linotype-Hell).

Live Image—a graphic image in an electronic mechanical which is intended to be output as it appears in the layout, implying that the image file contains all information necessary for high-quality output.

Local Area Network (LAN)—a group of computers linked together by cables, usually within the same room or building, so that they may share software resources and peripheral devices such as printers and hard drives.

Logic—a data processing scheme for computers based on rules for logical thought formulated by George Boole in 1854. A way to follow Boole's rules mechanically, utilizing logical algebra and binary numbers, was devised in 1937 by Claude Shannon. The most basic of logic rules for a computer are incorporated in the concepts of AND, OR and NOT.

Machine Spot—see Laser Spot.

Masking Sheet—any material, such as goldenrod paper, used to cover up portions of a negative or plate to prevent imaging.

MatchPrint—a type of digital proof developed by 3M.

Math Co-Processor—a processing unit installed in addition to the main processor to specifically handle mathematical operations. A math co-processor (also known as a floating point unit or FPU) can expedite the processing of graphics operations and is necessary to operate certain filters in Adobe PhotoShop and Adobe Illustrator.

Mechanical—an assemblage of typographic and graphic elements which represents the final form of a publication, ready to be converted into negatives and printing plates. See Camera-Ready Art and Electronic Mechanical.

Mechanical Screen—another term for halftone screen, more often used to describe a tint screen rather than a photographic halftone.

Megabyte (MB)—a measurement of digital data equal to 1024 kilobytes.

Megahertz (MHz)—a measurement of the clock speed of a computer as in 24MHz, 33MHz, etc.

Microprocessing Chip—the main processing unit of a microcomputer, such as those made by Motorola for the Macintosh and by Intel for the PC.

Microsoft Windows—software developed by Microsoft to provide a graphical user interface (GUI) for computers using DOS.

Mid-Range Prepress Systems—electronic prepress systems that can be classified as occupying a position midway between high-end and desktop publishing systems in performance and cost.

Misregistration—a condition occurring on a printing press when the edges of adjacent colors do not precisely match each other, creating a gap that allows paper color to show through.

Modem—a device that allows the transmission of computer data over telephone lines.

Moiré—an unwanted pattern appearing in printed halftones when incorrect screen angles are used; may also appear in halftoned photographs of textiles and other textured surfaces.

Monitor—the display unit of a computer, usually a cathode ray tube (CRT).

Monochrome—a single color.

Mouse—an input device used with a graphical user interface (GUI) to manipulate a cursor in a nonlinear fashion.

Mouse Button—the button(s) on a mouse that extend its functionality.

Mouse Cursor—the symbol (often an I-beam or an arrow) appearing on a computer screen and moving in response to movement of the mouse.

Nudge Buttons—software controls operated by clicking with the mouse cursor to perform incremental manipulations, such as positioning of graphic elements and typographic specifications.

Object-Oriented—see Vector Image.

Off-Press Proof—any proofing method that attempts to show color, etc. without actually printing the publication.

Offset Printing—the method of printing in which ink is transferred from a plate to a rubber blanket and then from the blanket to the paper. Also known as offset lithography.

Open Prepress Interface (OPI)—a system developed by the Aldus Corporation (now Adobe Systems, Inc.) for allowing high-resolution digitized images to be automatically incorporated into desktop publications.

Operating System—the software instructions that operate a computer and perform essential background functions such as memory management and providing a structure for user-controlled software applications.

Optical Drive—a storage device utilizing a laser to read and write data.

OS/2 (Operating System 2)—a "second-generation" operating system developed by IBM as an alternative to MS DOS.

Output Device—any device such as a laser printer, imagesetter, or film recorder used to output computer-generated documents or images.

Output Resolution—the measurement of image resolution in dots per inch (dpi) which determines image quality.

Overlay Proof—a process color proof, such as the 3M Color Key, consisting of a separate overlay of acetate film for each color.

Overprinting—to print one ink on top of another.

Page Layout Software—software applications, such as PageMaker and QuarkXPress, designed to provide tools and functions for creating electronic mechanicals.

Painting Software—software applications, such as Fractal Design Painter, designed to provide tools and functions for creating bitmap image illustrations.

Pantone Matching System (PMS)—a color matching system used in the graphics industry to specify premixed printing ink colors by number.

Pasting Up—the process of creating a traditional mechanical by adhering pieces of paper to a stiff paper backing with glue or adhesive wax.

Personal Computer (Microcomputer)—any computer designed for ease of use by an individual in business or recreational activities.

Photomechanical Process—the process of creating film or PMTs by photographing traditional mechanicals or original art with a reprographics camera.

Phototypesetting—the process of creating type for use in a mechanical that images the characters on photosensitive paper.

PhotoYCC—a color model developed by Eastman Kodak for use in the Photo CD technology.

Pixel (Picture Element)—the smallest controllable spot on a computer screen.

Pixel Depth—a measure of the ability of a pixel to display levels of gray depending on its bit depth.

Placeholder Image—an image in an electronic mechanical intended to be replaced by another image or a higher resolution version of the same image. See For Position Only (FPO).

Plateless Printing Press—a digital press utilizing laser technology and colored toner, able to reproduce full color publications directly from a computer and raster image processor (RIP).

PMT (Photo-Mechanical Transfer)—a photographic process developed by Kodak for making positive paper prints of halftones and other graphic images.

PostScript—the page description language developed by Adobe Systems, Inc. that has become a standard for the electronics prepress industry.

Power Macintosh—the line of Macintosh computers based on RISC (Reduced Instruction Set Computing) architecture.

Prepress Service Bureau—see Service Bureau.

Press Check—to view a publication as the first copies are printed to ensure that colors and other elements are correct.

Press Form—the form of pages as they are printed on a printing press, determined by paper size and imposition. See Signature.

Press Layout—the layout of pages as they will print on a printing press, often differing from the way the pages were laid out in the design process. See Press Form.

Press Proof—press runs of a printing job made prior to actual production to check color quality and other elements.

Printer Font—a font file downloaded to the output device when a publication is printed.

Printing Plate—in offset lithography, a metal or plastic sheet having a photo-sensitive surface and carrying the image to be printed.

Process Camera—see Reprographics Camera.

Process Colors—the four ink colors used most often for full-color printing—cyan, magenta, yellow, and black (CMYK).

Process Color Model—a software function allowing cyan, magenta, yellow, and black (CMYK) to be selected and mixed for use in an electronic mechanical.

Process Color Separations—the result of outputting a publication or image so that each of the process colors (CMYK) is represented on a separate piece of paper or film.

Progressive Proof—a press proof in which each color is printed separately and in various combinations to check for color fidelity, dot gain, trapping accuracy, and so on.

Proof—a representation of a publication or image made prior to final printing intended to reveal flaws and errors, predict results, and establish a standard to be matched on the press.

Proprietary Software—software functioning only on a computer system designed by the software's vendor.

Proprietary System—a digital system requiring components, including software, to be purchased and supported by a single vendor, usually not compatible with any other system.

Pull-Down Menu—a visual device in a graphical user interface (GUI) displaying commands activated by the mouse or keyboard.

RAM (Random Access Memory)—temporary memory that stores data and instructions in a computer while it is turned on.

Random Screening—see Stochastic Screening.

Raster Image—another term for bitmap image, referring to the process of rasterization in which the image is converted from digital data (pixels) to laser spots in an imagesetter or film recorder.

Removable Cartridge Drive—a type of computer data storage device utilizing a removable and portable magnetic disk (cartridge) allowing data to be easily transferred to another location.

Reprographics Camera—a specialized camera for the graphic arts providing highly accurate reproduction of original art and mechanical layouts onto a film base, now largely replaced by scanners, imagesetters, and film recorders.

Resolution—the relative visual quality of a digital image, determined by the bit depth of pixels, the number of pixels in the image, and the mechanical parameters of the output device. Low resolution implies roughness and lack of detail; high resolution implies sharpness and clear details.

Reverse Type—white type on a background color or shade.

RGB Model—a software function allowing red, green, and blue to be specified and mixed to create colors for display on a computer monitor.

RIP (Raster Image Processor)—a device for converting PostScript code from a desktop publishing system into high-resolution bitmap images which are rendered by an output device or digital press onto paper, film, printing plate material, or an electrostatic drum.

RISC (Reduced Instruction Set Computing)—a microprocessing chip architecture in which the chip contains only the most common instructions needed to process data, allowing the computer to operate much faster. More complex instructions are processed and simplified by the software itself, requiring that software applications be compiled specifically for a particular RISC chip.

ROM (read-only memory)—a permanent type of computer memory that stores key data and cannot be changed or erased.

Rule—the term often used in graphic arts to describe a line.

Scanned Image—see Digitized Image.

Scanner—a device for converting black and white, gray, and colored images into digital data. Some scanners are able to utilize optical character recognition (OCR) to read type characters on paper and convert them to digital text files

Scanning Resolution—the determination when digitizing an image of the number of pixels it will contain.

Screen Angle—the angle of the rows of dots or cells in a halftone screen, especially critical in process color printing where each screen must be at a different angle.

Screen Font—a font file which displays type characters on a computer screen.

Screen Frequency—the number of lines or rows of dots per inch in a halftone screen, stated as lines per inch (lpi). Also known as screen ruling.

Screen Ruling—see Screen Frequency.

Scroll Bars—software controls in a graphical user interface (GUI) that allow the contents of a window to be moved (scrolled) horizontally and vertically.

Service Bureau—a commercial business providing output services for desktop publishing.

Short Run Printing—printing a relatively small quantity of a publication.

Signature—a sheet of printed pages to be folded and bound to create a publication. The arrangement of pages in a signature is determined by the press form which is created when the pages are imposed during the stripping process.

SIMM (Single Inline Memory Module)—a unit of computer chips providing random access memory (RAM).

Sneakernet—a humorous term describing the process of hand-carrying a computer disk to transfer information among computers, deriving from the slang term, "sneaker" (a rubber-soled athletic shoe), and the term, "network," as in a computer network.

Soft Proof—an image displayed on a computer screen used as a proof.

Software Application—a set of coded instructions that a computer uses to perform specific functions controlled more or less by the user.

Software Link—software designed to provide a link, or gateway, between desktop publishing systems and high-end color electronic prepress systems (CEPS).

Spot Color—color other than process color, usually limited to one to three colors of ink printed in solids or tints.

Stat—abbreviation of photostat, a process similar to PMT for making positive prints of halftones and other graphic images.

Stochastic Screening—the process of imaging full-color continuous-tone art to be printed with screens of random laser spots rather than halftone cells. Also known as FM (frequency modulated) screening or random screening.

Storage Memory—permanent or semi-permanent memory for data generated by a computer, usually in the form of magnetic or optical disks or tape.

Stripping—the process of assembling negative (and positive) film into flats prior to making printing plates.

Subtractive System—usually refers to the process color model (CMYK) in which equal parts of cyan, magenta, and yellow make black (although not a true black).

Supercell Technology—special digital halftone screening technologies developed by Adobe Systems, Agfa, Linotype-Hell and others.

SWOP (Specifications for Web Offset Publications)—professional standards for offset printing in the United States.

T-Square—a mechanical drawing device used by draftspersons to maintain consistently precise right angles.

Telecommunications—the process of using a modem to transmit computer data over the telephone lines.

Thermal-Wax Printer—a color output device utilizing a waxy pigment bonded to paper with heat.

TIFF (Tag Image File Format)—a computer file format developed for scanned images.

Tint Screen—a halftone screen consisting of dots or cells of uniform size used to print tints of a color.

Token-Ring Network—a type of local area network (LAN) connecting computers and other devices in a closed ring allowing a software token to be passed to each computer, giving it access to other devices on the network.

Trackball Mouse—a mouse operated by rolling a ball mounted on the top surface.

Tracking—a procedure for adding or deleting space between type characters.

Trapping—see Color Trapping.

Trapping Values—the numerical values used to specify how much colors will overlap in the trapping process.

Triangle—a mechanical drawing device used with a T-square to draw lines at precise angles.

Type Galley—a sheet of paper containing typeset text intended to be cut apart and pasted up in a mechanical.

Type Style—a variation within a type family, such as italic, bold, etc.

Under Color Addition (UCA)—adding cyan, magenta, or yellow ink to shadows in a printed image to increase the saturation of color (thereby increasing the richness of the shadow).

Under Color Removal (UCR)—a solution to the problem of excess ink coverage (ink trapping) in process color printing that reduces the cyan, magenta, or yellow ink wherever black is going to print.

UNIX Workstation—a minicomputer utilizing the UNIX operating system. UNIX is a variation of UNICS (UNified Information and Computing System), a system developed at AT&T Bell Labs. UNIX is a complex operating system that provides sophisticated built-in functions such as multitasking.

Vector Image—a graphic image created in a drawing software application characterized in appearance by distinct shapes, lines, and fill patterns and having its output resolution determined by the output device. Also called object-oriented image.

Video Card—a computer circuit board that controls the computer's monitor.

Virtual Memory—a form of random access memory (RAM) created on the hard drive by a computer's operating system.

VRAM (Video Random Access Memory)—special RAM utilized by a computer's monitor.

Wide Area Network (WAN)—a computer network spread over a large geographical area.

Word Processing Software—a software application designed for easy and rapid entry and manipulation of textual information, providing typographic, search and replace, spell checking, form letter and many other features.

WORM (Write Once, Ready Many) Drive—a computer data storage device that allows information to be written on a disk and read from the disk, but not changed in any way.

WYSIWYG (What You See Is What You Get)—refers to a situation in which an image seen on a computer's monitor accurately reflects how the image will look when printed.

Index